Photoshop 5.5

A *to* Z

The essential visual reference guide

Peter Bargh

Focal Press

OXFORD • AUCKLAND • BOSTON • JOHANNESBURG • MELBOURNE • NEW DELHI

Words and design: Peter Bargh
All photographs: Peter Bargh, unless stated
Design concept and cover: Steve Handley
e-mail peter@bargh.globalnet.co.uk

Focal Press
An imprint of Butterworth-Heinemann
Linacre House, Jordan Hill, Oxford OX2 8DP
225 Wildwood Avenue, Woburn, MA 01801-2041
A division of Reed Educational and Professional Publishing Ltd

A member of the Reed Elsevier plc group

First published 2000

© Peter Bargh 2000

British Library Cataloguing in Publication Data
A catalogue record for this book is available from the British Library

Library of Congress Cataloguing in Publication Data
A catalogue record for this book is available from the Library of Congress

ISBN 0-240 516 31 1

Acknowledgements

Ian Jennett – introduced me to Photography.
William Cheung – gave me my first job in Journalism.
Jonathan Whittle – had the confidence to let me launch
and edit *Digital PhotoFX* magazine.
Steve Handley for design concept and assistance throughout.
Chris Robinson for initial design ideas and moose.
Jeremy and Suzanne at Adobe PR – for keeping me up to date.
Future Sound of London, Sunscreem and Popol Vuh – for music while I worked.
And finally Katie for making my life so very special.

Printed and bound in Great Britain

FOR EVERY TITLE THAT WE PUBLISH, BUTTERWORTH-HEINEMANN
WILL PAY FOR BTCV TO PLANT AND CARE FOR A TREE.

Introduction

Photoshop is one of the most complex image editing programs sold, and many of the reference books are equally complex. *Photoshop 5.5 A to Z* has been produced to present the program in a visual way and in a logical order.

It's too easy to get lost wading your way around a 300 page book trying to find out how a certain feature works. Here you look up the mode, tool or filter, presented in a logical A to Z order, to find a visual reference with handy tips and quick keys.

The book can be used as a helpful guide to keep near your computer, giving you nuggets of essential information as you work. It will also give you plenty of ideas to try on your own pictures.

It's also worth noting that I'm an English author and would normally prefer to use English spellings, for example colour instead of color, but as the book will be sold throughout the world I've decided to adopt the US spelling for the word color. This ensures the book is consistent with the Photoshop users' manual and interface.

I've also used Apple Mac commands throughout the book, simply because I've used a Mac for years in favour of the PC. Essentially Photoshop runs the same whichever platform you work on. The main difference is when a keyboard shortcut includes the Command key on a Mac you would use the Ctrl key on a PC. Similarly when the Option key is used on a Mac the Alt key should be used on the PC, and the Return key on the Mac is Enter on the PC. Enjoy!

Peter Bargh, 2000

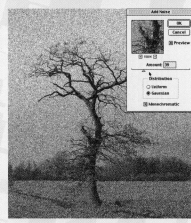

Contents

Actions

MENU **WINDOW →**
 SHOW ACTIONS
QUICK KEY **F9**

An action is a way of automatically applying a technique to an image using a pre-recorded series of commands, or script, that is triggered by pressing one or a combination of keys. Many actions are already supplied with Photoshop and may be as simple as opening a new canvas or as advanced as creating a drop shadow on an existing picture.

You can also create your own Photoshop actions using the Automate mode, so if there are techniques you find particularly fiddly or ones you'll want to use again and again, record the commands as you run through them and assign the action a shortcut key.

To record a new action open an image and select New Action from the hidden menu or click on the page icon at the bottom of the palette. This displays a new palette. Name your action, choose a destination folder, a shortcut key and a color for the button display.

The shortcut can be a single F button or any combination of an F along with Shift and Control keys. Click on the record button and run through the various steps to produce the desired result. You'll see each step appear in the menu as it's recorded. When you've finished click stop.

Now whenever you want to apply the recorded effect just click on the designated shortcut key. Actions can also be applied to several images in one go using the Batch command.

(See Batch command)

ACTIONS PALETTE
is displayed by going to Window→Show Actions. From here you can turn part of an action on or off, as well as record, play or edit new or existing actions.

BUTTONS DISPLAY
You may prefer to view the more colorful buttons display. Select this from the Actions menu, called up by clicking on the triangle at the top right of the palette.

Tips

● If a command cannot be recorded you can insert it manually using the Insert Menu command.
● If you make a mistake, keep going, you can edit the script later.
● Some settings may need modifying for different images. Clicking on the box to the left of the action will stop the script at that point and bring up the dialogue box so you can manually adjust before continuing the script.

Airbrush

QUICK KEY **J** SELECTS IT
FROM TOOLBOX

A painting tool that applies a color in much the same way as a real airbrush.

Hold down the mouse and drag it around to spray the color evenly onto the canvas. Hold it in the same place and the color builds up and spreads outwards.

Covering an area that's already sprayed builds up color.

As with all brush modes you can specify size, blending mode and opacity using the Options and Brushes palettes that are called up from the Window menu.

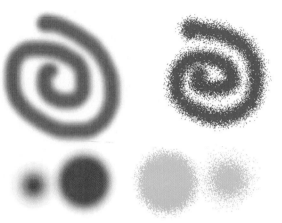

Tips

- Select a start point, hold down the Shift key and click an end point to paint a straight line.
- Use the Airbrush on low pressure with black paint to create shadows.
- Switch on Caps lock to turn the Airbrush standard cursor into a precision crosshair.

Alpha channels

Are ideal for saving selections separate from the RGB or CMYK channels. Carefully draw round a subject and chose Select→Save Selection once you're happy with the selection. This is then stored at the bottom of the Channels palette as a separate channel, known as the Alpha channel.

It can be recalled and the selection applied to the image at any time by calling up Load Selection from the Select menu. This saves you having to reselect a subject later. Up to 21 Alpha channels can be added to an RGB image allowing you to produce very complex selections that can be recalled to make changes to a variety of detailed parts of the image at any time.

Alpha channels can also be used to store fifth color info for special printing jobs.
(See Channels)

Tip

- Alpha channels can be combined to add selections together.

Apply image

MENU **IMAGE →** Used to blend one
 APPLY IMAGE image layer and
channel with another.
(See Calculations)

Anti-aliasing

Aliasing occurs when the sharp edges of pixels appear jagged on the straight edges of an image or text.

Pixels can make smooth edges look jagged.

Photoshop uses anti-aliasing to smooth out the edges by making the pixels semi-transparent so that they pick up color from surrounding pixels. It's useful when cutting or copying and pasting selections onto new backgrounds. Anti-aliasing can make the image look a little blurred when viewed close up.

Artifacts

Digital photography, like any form of image capture, can produce faults. In digital photography they're referred to as artifacts and can be caused by a number of problems including flare from the camera's lens, electrical interference or low resolution CCDs. Low resolution CCDs cause curved edges to appear jagged as the curve takes on the square edges of each pixel – known as Aliasing.

Blooming is less of a problem now but occurred on earlier CCDs when the electrical charge exceeded the pixel's storage capacity and crossed into adjacent pixels causing image distortion. We've all seen the TV presenter with the stripy shirt appearing as a strange colored pattern. The same thing happens on CCDs and it's known as color fringing.

a

Art History Brush

QUICK KEYS SHIFT+Y

ALTERNATES BETWEEN

HISTORY AND ART

HISTORY BRUSHES

A new feature of Photoshop 5.5 that will appeal to artists as, with a little experimentation, it can create some stunning painterly effects.

You choose from a variety of patterns and select the Blending mode and opacity before painting over an existing image. The more you paint over the same area the greater the effect. The larger the brush size the bigger the paint daubs and less realistic the effect.

Colorful images like this are suitable for the Art History Brush attack.

With a small brush and careful choice of the palette options paint effects can be very realistic.

Choose too large a brush size and the effect could go completely wrong. You could use this sort of treatment as background to text, though.

Although this isn't a particularly stunning example (I never said I was a painter!) it shows you can get depth by painting over larger brush strokes.

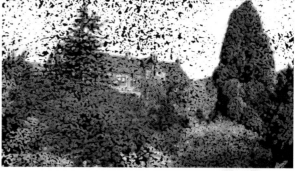

Try filling the picture with a color (black in this example) and paint from the previous history state on the colored fill.

Tip

● Using one of the other custom brushes from Photoshop's Goodies folder will produce more unusual results.

Here the cross brush was used to give a pastel/starburst effect.

Setting Fidelity to a low value produces brush strokes that have more color than the source point (left). A high value maintains the source color (right).

Artistic filters

MENU **FILTER →**
 ARTISTIC →
Change your picture into a painterly image using this batch of filters that mimics natural or traditional artists' effects.

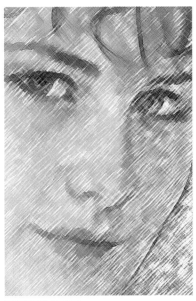

COLORED PENCIL
Produces a rough crosshatch effect by drawing over the original using colored pencils. Edges are retained and the original background image shows through the pencil strokes.
Pencil Width: 2, Stroke Pressure: 13, Paper Brightness: 50

CUTOUT
Builds up the image as though it's created by a collage of several pieces of torn colored paper. It has a similar look to a posterization effect.
Number of levels: 7, Edge Simplicity: 1, Edge Fidelity: 3

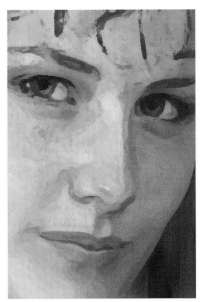

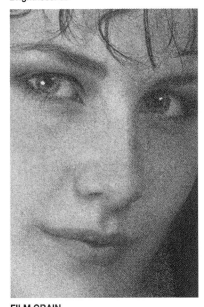

DRY BRUSH
Paints edges using a dry brush technique that appears midway between an oil and watercolor effect. The range of colors is simplified as the filter looks at nearby pixels and blends them into areas of common color.
Brush Size: 10, Brush Detail: 7, Texture: 2

FILM GRAIN
Applies a pattern of grain that simulates real film. The higher you set the grain the more like fast film the effect becomes.
Grain: 7, Highlight Area: 8, Intensity: 1

FRESCO
Converts the image into a coarse stippled effect using short, rounded, and quickly applied brush dabs. Good for a Classic painting effect.
Brush Size: 0, Brush Detail: 9, Texture: 3

a

NEON GLOW
Adds a glow to parts of the image. The glow color is selected by clicking the glow box and choosing a color from the color picker.
Size: -3, Brightness: 23, Color: Red

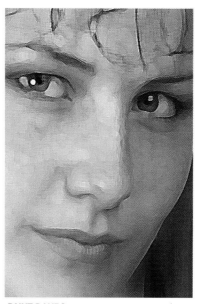

PAINT DAUBS
A nice effect varied by altering the brush size to between 1 and 50, with a selected brush type that includes simple, light rough, light dark, wide sharp, wide blurry and sparkle.
Size: 11, Sharpness: 32, Brush Type: Simple

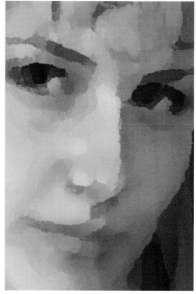

PALETTE KNIFE
Similar to cutout, but with more blurred edges to emulate a palette knife style of painting. Will only suit certain images.
Stroke Size: 24, Stroke Detail: 3, Softness: 10

ROUGH PASTELS
Makes an image appear as though it's on a textured background, covered in colored pastel chalk strokes. Chalk appears thick with little texture in bright colored areas and thinly sketched in darker areas.
Stroke Length: 10, Stroke Detail: 14, Texture: Sandstone, Scaling: 114%, Relief: 23, Light Direction: Left

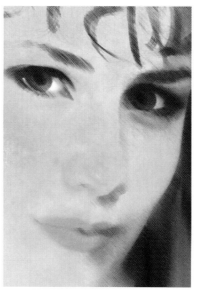

SMUDGE STICK
Uses diagonal strokes to smudge or smear the darker areas and soften the image while lighter areas become brighter and lose detail.
Stroke Length: 10, Highlight Area: 20, Intensity: 5

SPONGE
This is supposed to give an appearance of the image being painted with a sponge. Hmmm!
Brush Size: 8, Definition: 11, Smoothness: 8

PLASTIC WRAP
Create Terminator style morphing by coating the image with a shiny plastic effect that ccentuates surface detail.
Highlight Strength: 20, Detail: 13, Smoothness: 7

POSTER EDGES
Creates poster style effects by reducing the number of colors in the image and adding black lines around edges.
Edge Thickness: 10, Edge Intensity: 3, Posterization: 0

Auto Contrast

MENU	IMAGE →
	ADJUST →
	AUTO CONTRAST

Auto mode that looks at the brightest and darkest parts of the image and adjusts the picture's highlights and shadows. It works well on some images, but it's often better to adjust the picture using Levels or Curves. **(See Levels)**

BEFORE AFTER

Auto Levels

MENU	IMAGE →
	AUTO →
	LEVELS

Scanned images using the auto setting rarely turn out with correct color or density so you need to adjust brightness and contrast.

Auto Levels looks for the brightest and darkest points and adjusts contrast so both maintain detail. It's a quick and easy fix, but learning how to adjust Levels manually produces better results. **(See Levels)**

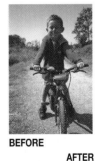

BEFORE

AFTER

UNDERPAINTING
Makes the image appear with a textured background that shows through the surface.
Brush Size: 18, Texture Coverage: 18, Texture: Canvas, Scaling: 90%, Relief: 12, Light Direction: Bottom

WATERCOLOR
Saturates colors and paints in a watercolor style by simplifying image detail. Can become too contrasty if you're not careful.
Brush Detail: 13, Shadow Intensity: 2, Texture: 1

Automate

MENU	FILE →
	AUTOMATE

A series of pre-written auto tasks used to make contact sheets, multi-format prints, batch conversions and format pictures for your Web page.

b

Background color

QUICK KEYS X ALTERNATES BETWEEN BACKGROUND AND FOREGROUND COLOR The default is white which appears in the lower box of the tools palette. You can change the color from white by clicking on this box and using the color picker to select a new one. One reason for doing this is when making gradient fills which progress from the foreground to background color. Erasing part of an image leaves the background color.
(See Foreground color)

Tip
● To fill a selection with the Background color press Command→Delete.

Background Eraser

New Photoshop 5.5 feature that makes selections even easier. Simply rub over the area you don't want and the Eraser makes it transparent. Then when you copy and paste to a new layer it will look more natural.

Discontinuous erases the sample color wherever it appears in the picture. Contiguous erases pixels that are connected and Find Edges preserves edge sharpness.

Tip
● Change the tolerance level when working on different areas of the image. A higher percentage can be selected when there's a definite variation between the edge of the selection.

Batch processing

MENU **FILE →**
 AUTOMATE →
 BATCH

If you've ever had to deal with a pile of images that all needed converting from one format to another or one color mode to another you'll welcome this feature with open arms. Batch processing takes a selection of images from a folder and performs action sequences that you've pre-recorded in the Actions palette. You can specify whether you want the processed files to replace the existing ones or create new versions in a different destination folder. **(See Actions)**

Tips

● Reduce the number of saved history states and deselect the Automatically Create First Snapshot option in the History palette for better batch processing.
● To change formats when batch processing make sure you include a Save As command in the original action sequence and close the file. Then choose None for the destination when setting up the batch process.

Bevels

MENU **LAYER →**
 EFFECTS →
 BEVEL & EMBOSS

A mode that produces stylish type that will leap off your page. It can also be used on colored shapes to create 3D panels and buttons. Using the Effects palette you can adjust the highlight and shadow of the bevel to create shallow or deep 3D effects.

Results vary depending on the resolution of your image so experiment with the settings to find a suitable effect. Turn Apply on so you can see the changes as you play. To get you started here are several I made using a 7x3cm canvas with a resolution of 300ppi and 50 point text.

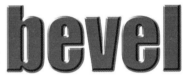

A NICE DEEP ROUNDED TEXT
Highlight Mode: Normal, Opacity: 100%, Color: white, Shadow Mode: Multiply, Opacity: 50%, Color: black, Style: Emboss, Angle: -45°, Depth: 20, Blur: 5, Down.

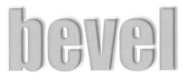

PLASTIC LETTER EFFECT
Highlight Mode: Darken, Opacity: 100%, Color: green, Shadow Mode: Color burn, Opacity: 45%, Color: deep blue, Style: Pillow Emboss, Angle: 23°, Depth: 10, Blur: 9, Down, Use Global Angle.

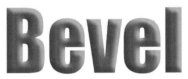

A STONE SORT OF THING!
Highlight Mode: Multiply, Opacity: 100%, Color: blue, Shadow Mode: Luminosity, Opacity: 66%, Color: yellow, Style: Inner bevel, Angle: 45°, Depth: 20, Blur: 17, Down, Use Global Angle.

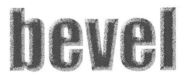

...OR MAYBE SOMETHING PEBBLE DASHED
Highlight Mode: Dissolve, Opacity: 100%, Color: yellow, Shadow Mode: Dissolve, Opacity: 80%, Color: green, Style: Inner bevel, Angle: -40°, Depth: 20, Blur: 10, Down.

Bevels settings explained

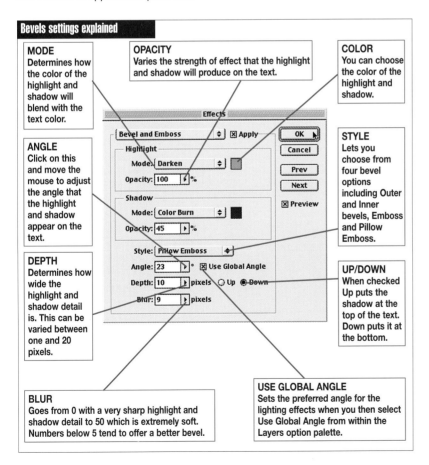

MODE
Determines how the color of the highlight and shadow will blend with the text color.

OPACITY
Varies the strength of effect that the highlight and shadow will produce on the text.

COLOR
You can choose the color of the highlight and shadow.

ANGLE
Click on this and move the mouse to adjust the angle that the highlight and shadow appear on the text.

STYLE
Lets you choose from four bevel options including Outer and Inner bevels, Emboss and Pillow Emboss.

DEPTH
Determines how wide the highlight and shadow detail is. This can be varied between one and 20 pixels.

UP/DOWN
When checked Up puts the shadow at the top of the text. Down puts it at the bottom.

BLUR
Goes from 0 with a very sharp highlight and shadow detail to 50 which is extremely soft. Numbers below 5 tend to offer a better bevel.

USE GLOBAL ANGLE
Sets the preferred angle for the lighting effects when you then select Use Global Angle from within the Layers option palette.

b

Bézier curves (bay-zee-ay)

Curves created using Photoshop's Pen tool are called Bézier curves, named after French mathematician Pierre Bézier.

The shape of a curve is created by the position of anchor points and direction lines that can be moved to change its shape and direction. They're used to make perfect selections around smooth or curved objects.

Bicubic interpolation

Used to increase the image size by adding pixels based on the average of the colors of all eight surrounding pixels. It also boosts contrast between pixels to avoid a blurring effect that's usually evident from interpolation. It's the slowest of the three interpolation processes, but it's the most precise and gives the smoothest gradation between tones. **(See Interpolation)**

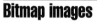

Tip

● To ensure Bicubic is selected as a default go to File→Preferences →General and pull the option down in the interpolation box drop down menu.

Preferences

General

Color Picker: Nearest Neighbor (Faster)
Bilinear
Interpolation: ✓ Bicubic (Better)

Options
☒ Anti-alias PostScript ☐ Beep When Done
☒ Export Clipboard ☒ Dynamic Color Sliders
☐ Short PANTONE Names ☒ Save Palette Locations
☒ Show Tool Tips

Reset Palette Locations to Default

OK
Cancel
Prev
Next

Bitmap mode

MENU IMAGE →
 ADJUST →
 BITMAP

Converts the picture into a grid of black & white pixels. The option won't be available if you're trying to convert a color image. Discard color first by selecting Image→Mode→ Grayscale. Set output in the dialogue box to your inkjet printer's resolution.

Bitmap images

An image made up of a grid of squares (pixels) also known as a Raster image and not to be confused with Bitmap mode.

Bitmap images are resolution-dependent which means the number of pixels used to make up the image is fixed.

A bitmap is good at reproducing subtle colors, but jagged effects can occur when the image is enlarged.

Bitmap

Resolution
Input: 300 pixels/inch
Output: 300 pixels/inch

Method
⦿ 50% Threshold
○ Pattern Dither
○ Diffusion Dither
○ Halftone Screen...
○ Custom Pattern

OK
Cancel

GRAYSCALE
The color image converted to grayscale using
Image→Mode→Grayscale.

50% THRESHOLD
Pixels with grey values above mid-grey convert
to white and the rest become black resulting in
a very high contrast, black & white image.

PATTERN DITHER
Converts the image into a geometric pattern of
black & white dots that produce a range of
grays when viewed.

DIFFUSION DITHER
Produces a film-like grain that's useful for
viewing images on a black & white monitor.

HALFTONE SCREEN
Converts a grayscale image to simulate a
printer's halftone dots.

CUSTOM PATTERN
First define your own pattern and then apply
this pattern as a texture screen.

b

Blending modes

A range of modes selected from within the Options or Layers palettes. The modes control how the pixels in the base image are affected by a Brush, Editing tool or other Layer.

Here's what happens when a leaf is blended with a stained glass window.

The leaf was cut out from its background and placed on a separate layer to the stained glass window. Then various Blend modes were applied.

NORMAL: Opacity 50%
The default mode, which appears as Threshold when you're working with bitmap or indexed color images. When the layer or brush is set at 100% the pixels produce the end color and are not affected by the base image. Change the opacity and the colors blend and form an average.

DISSOLVE: Opacity 65%
When two layers are combined there's no effect unless the active layer has been feathered and then a splattering effect appears in the feathered area to produce the dissolved colors.

COLOR: Opacity 100%
Produces an end color with the luminance of the base color and the hue and saturation of the blend color. It's a good mode for hand-coloring black & white images as it keeps the gray tones.

COLOR DODGE: Opacity 100%
Uses the upper layer or paint to add color and brighten the color of the base layer. Blending with black doesn't affect the image.

EXCLUSION: Opacity 100%
A similar, but lower contrast effect to the Difference mode.

COLOR BURN: Opacity 85%
Merges the darker colors of the upper layer or paint with the base layer. Blending with white has no effect on the overall image.

DARKEN: Opacity 100%
Looks at the color in each layer and selects the darker of the base or blend layer as the final color. Lighter pixels are replaced, darker pixels stay the same.

DIFFERENCE: Opacity 100%
Looks at which color has the brightest value and subtracts the weaker. Blending with white inverts the base color, but black has no affect.

LUMINOSITY: Opacity 65%
Mixes hue and saturation of the base color and the luminance of the blend color and creates the opposite effect of Color mode.

LIGHTEN: Opacity 100%
Looks at the color in each layer and selects the lighter of the base or blend layer as the final color. Pixels darker than the blend color are replaced and lighter pixels stay the same.

HARD LIGHT: Opacity 70%
Adds color together and, like Soft Light, lightens image areas lighter than 50% grey and darkens the Blend color if it's already darker than 50% gray. Painting with black or white produces pure black or white. A Harsh overlay.

HUE: Opacity 100%
Produces a combined color that includes the luminance and saturation of the base color and the hue of the blend color.

MULTIPLY: Opacity 70%
Painting over the base color with the blend color produces a darker color. Painting with black changes the base color to black, while white leaves the color unchanged. Painting repeatedly over the same area produces progressively darker colors and is similar to coloring with a felt tip pen. The active layer becomes darker when this mode is selected.

OVERLAY: Opacity 100%
Similar process to Multiply, but Overlay holds onto the base color's highlights and shadows while mixing with the active layer to produce an image with more contrast. Use this mode with a Paintbrush to build up a hand-coloring effect.

b

SATURATION: Opacity 100%
Takes the hue and luminance of the base color and blends it with the saturation of the applied color.

Blur filters

MENU FILTER ➜

BLUR

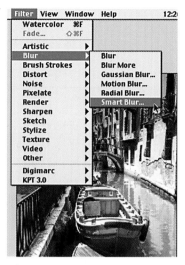

A series of effects accessed from the filter pull down menu and used to soften all, or part, of an image by reducing the defined edges between pixels. Quite silly really – you have a camera that's been carefully engineered to give razor sharp images that you're now going to make blurred! The beauty with a digital image is you can control how much and where the blur will occur. So consider having infinite control of depth-of-field or the ability to soften wrinkles and hide freckles while keeping the eyes sharp. Now you're thinking!

There are six options in the Photoshop filter menu that include Blur, Blur More, Gaussian Blur, Motion Blur, Radial Blur and Smart Blur.

SCREEN: Opacity 100%
Opposite performance to Multiply with the end color always lighter. Painting with black leaves the color unchanged while white produces white. The active layer becomes lighter.

SOFT LIGHT: Opacity 100%
Similar to Overlay, but more subtle. If the blend color is lighter than 50% gray, the whole image will lighten. If it's darker than 50% gray, the image will darken. How much depends on the paint color used. When you merge layers you benefit from a lighter image.

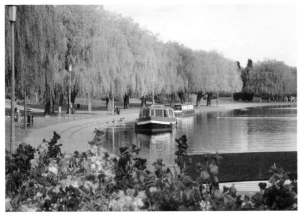

BLUR

Smoothes out color transitions in an image by averaging out pixels next to hard edges of defined lines and shaded areas. This is a good mode to help smooth out harsh looking pictures created using a digital camera.

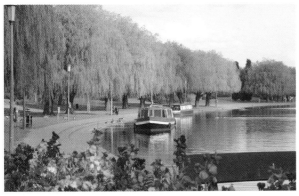

Straight shot from an Olympus Camedia digital camera.

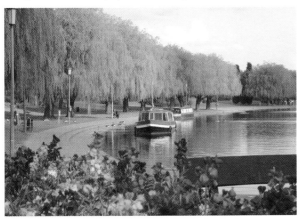

Blur filter applied.

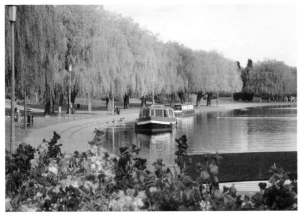

Fade Blur filter applied to give a more subtle blur.

BLUR MORE

Similar effect to the Blur filter, but up to four times as strong. The transfers on the car door have been enlarged so you can see the effect of the blur that's been added.

Original taken with a Nikon Coolpix 950 digital camera.

Blur More filter applied.

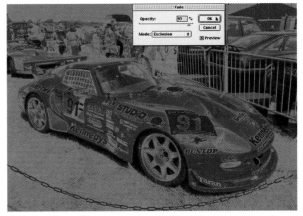

Fade Blur More with Blend mode set to Exclusion gives solarization.

b

GAUSSIAN BLUR

An adjustable blurring effect, controlled by one slider that adjusts the pixel radius in 1/10 pixels from 0.1 to 250. It adds low-frequency detail that can produce a hazy effect.

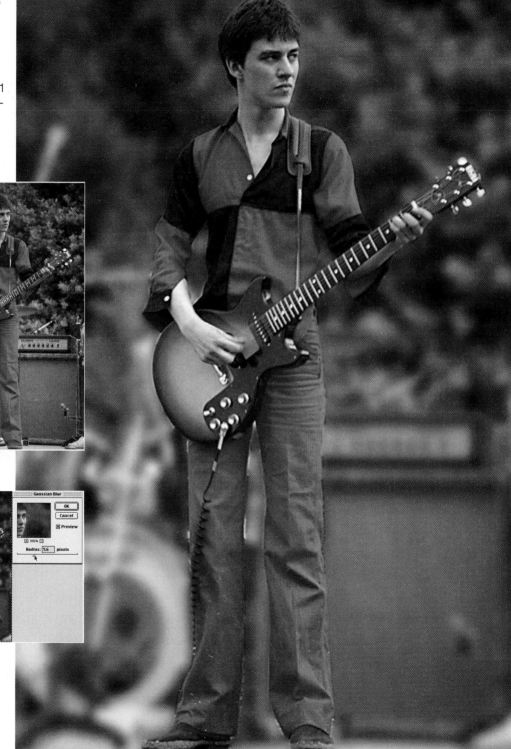

The picture in the preview window can be adjusted in size so you can watch the result on a localized area or the whole picture. The preview appears quicker if the area is magnified.

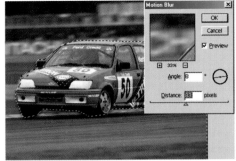

MOTION BLUR

Recreates slow shutter speed effects by blurring adjacent pixels at user selectable angles through 360°. You can also control the intensity of the blur producing a streak with a length of between 1 and 999 pixels.

RADIAL BLUR

Recreate zoom lens or rotating blurring effects with this mode. Ticking the Spin box makes the image look as though it's, wait for it, spinning. You then specify a degree of rotation by dragging the slider across while viewing

a graphical representation of the rotation. Tick the Zoom

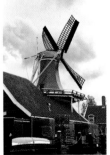

box to blur along radial lines and produce the same effect as adjusting a camera's zoom lens during a long exposure. You can adjust the depth from 1 to 100 pixels. You also have the option of Draft for fast, but grainy results or Good and Best for smoother results. Unlike in-camera effects you can also move the centre point of the effect off-centre by dragging the pattern in the graphic preview box.

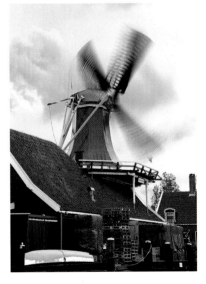

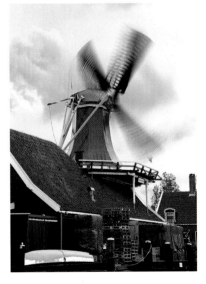

b

SMART BLUR

Smart Blur first appeared in Version 4 of Photoshop and leaves edges sharp while blurring lower contrast parts of the image, often resulting in a posterization or watercolor style effect.

Radius and Threshold sliders are provided to control the blurring effect by the depth of pixels affected and their values. There's also a quality box that has low, medium or high quality blur options. And a final box to set the filter to work on the entire selection in Normal

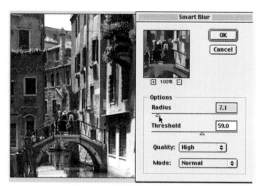

mode, or for the edges of color transitions using Edge Only and Overlay.

Edge Only produces a graphic black & white edge effect while Overlay Edge blends the graphical edge effect with the original image.

A careful blend of all four can produce some very creative images, but can also be used to reduce film grain or blemishes without affecting the overall result.

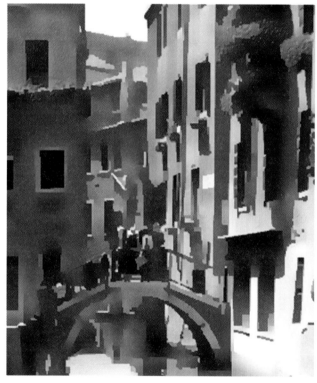

Tips
● Turn off Preserve Transparency in the Layers palette to apply a Blur filter to the edges of a layer.
● Create pencil drawings by running the Smart Blur set to Edge Only mode (middle). Then Invert Image▸Adjust▸ Invert to get a black sketch on white paper (right).

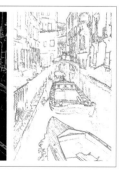

Borders

MENU	SELECT →
	MODIFY →
	BORDER

It's easy to add a border to your whole image or a selection. With an area selected choose the Border command and enter a width in pixels.

The thickness of border is relative to the original image size – a 3 pixel border on a 300 pixel wide image will look twice as thin as one with 600 pixel width.

When applied you'll have a second set of marching ants which you can fill using the Bucket tool or Edit▸Fill command. Choose the color border you want and set this as the foreground color before applying the fill.

Tips
● Don't go mad! Black or neutral colors can look more striking than a vivid red or blue. You don't want all the attention on the border!
● Thin borders set a picture off – thick ones can be messy.
● Borders made using the Border mode always have a softer inner edge. To produce a sharp defined border use the Stroke command.
(See Stroke)

Brightness

MENU IMAGE ➜
 ADJUST ➜
BRIGHTNESS/CONTRAST

Adjust the intensity of the image using this slider control. You can go from −100 to +100 which gives the equivalent of about three stops exposure control that you'd experience using slide film. While this is a quick and easy option it's better to use Levels or Curves for more precise control.

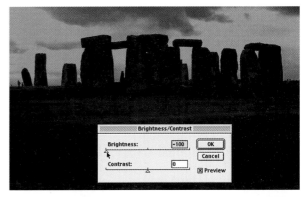

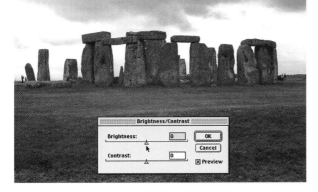

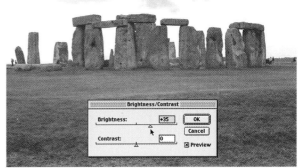

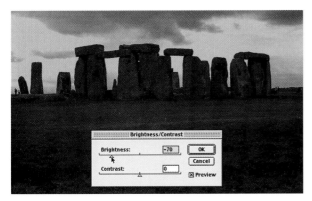

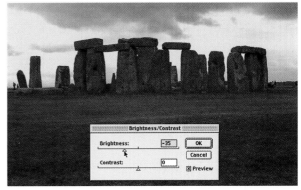

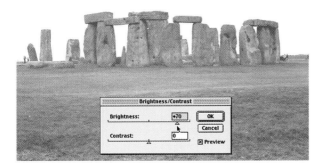

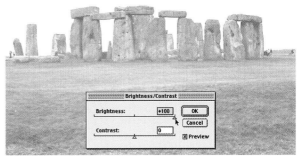

Brush creating

A useful feature hidden away within Photoshop's brush options palette is the Define Brush mode, accessed by scrolling

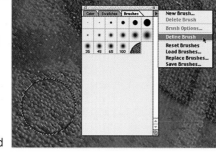

down a list from the black triangle at the top. Selecting part of any image, followed by Define Brush, will allow the selection to be used as a brush pattern. You can also create your own simple graphics and use them as a brush pattern.

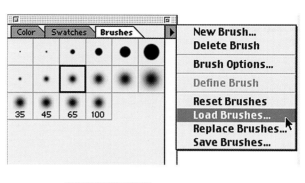

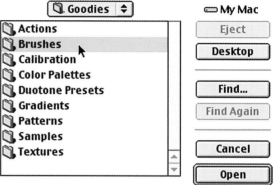

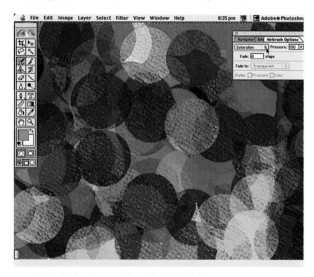

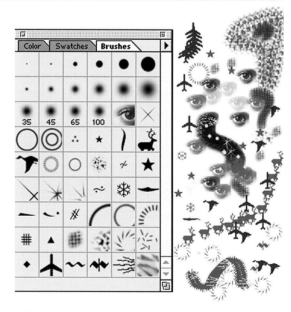

Above: You can also use the pre-set range of brushes that need to be loaded from Photoshop's Goodies folder.

Left: Make a selection from a suitable area of an image. Then choose Define Brush and start to paint. Saturation mode was used to create the colorful canvas, above, which was then treated to Motion Blur to create the background image, below.

Brush editing

The 16 brushes that appear as standard in the brush palette can be edited and added to. Double clicking on one brings up an editing palette where you can choose the diameter, hardness and spacing of the brush. You can also choose the angle and roundness.

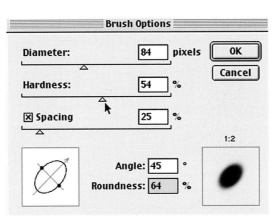

The diameter is selected in pixel width and can be anything from 1 to 999 pixels wide. Hardness determines how sharp the edge of the brush is and ranges from 0% to 100% Spacing varies the gap between each shape when you paint and can be set between 1% and 999%. A setting of 100% produces a shape that touches edge to edge, 50% overlaps by half so every alternate shape touches and 150% leaves a gap half the width of a shape between each shape. Got the idea? The angle comes into play when you've changed the roundness and is great for creating Calligraphy style brush strokes.

Brushes that have been created using Define pattern can only be edited using the Spacing control.

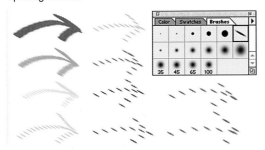

To illustrate the effect of the Spacing feature I first created an oblique shaped brush and increased spacing in increments of 100% for each of the arrows I've drawn on the canvas (left).

Brush size

MENU **WINDOW →**
SHOW BRUSHES
QUICK KEY **F5**

Varying the size of a paint brush is essential when working with different images. Where a large background may suit a chunky

brush, retouching a very small area would need a brush tip that may be just one pixel wide. This level of adjustment is made in the Brushes palette, which has a selection of pre-set sizes to choose from, but custom sizes can be also be created. It's not just paint brushes that benefit from size – you can also adjust the Eraser, Smudge,

Dodge & Burn tools, and, in this example, the Clone tool which made it much quicker to duplicate the boat. Its color was then changed.

Burn tool

QUICK KEY **SHIFT+0** A few of Photoshop's tools are based around the conventional photographer's aids and the Burn tool's one of them.

Drag this icon, that's shaped like a hand making an O shape, over the image to darken it – like you would in the darkroom using card with a hole cut out to let more light onto the paper.

You have a choice of how the Burn tool affects the image. Highlight darkens the light parts of the image, Midtones affects the mid-grays and Shadows adjusts the dark parts.

Toggle between the Burn, Dodge and Saturate icons using Shift+O.

Button mode

A pretty looking interface that's an alternative to the normal Actions palette and is selected from the black triangle drop down menu. Each Action is assigned a color, making it easy to group similar Actions. This mode is useful for less experienced users of the Actions feature, but scripts can't be edited so more advanced users should stay clear. **(See Actions)**

Calculations

MENU IMAGE →
 CALCULATIONS

This mode lets you merge two channels from one or two images and save the result as a new channel in one of the existing images or create a new image. The Calculations palette gives you various options including Blend method and is useful if you want to combine masks or selections.

Calibration

The phrase 'what you see is what you get', or 'wysiwyg' (pronounced whizzywig) couldn't be more important. When you view an image on the computer screen you want it to appear exactly the same when it prints out – oh if life were so simple! Computer monitors can be wildly out – just like your neighbour's television, and a high contrast, vivid color image on screen is likely to be disappointingly dull when printed.

It's because the image on the monitor is an RGB file that's projected light, while the printed image is a CMYK version that you view by reflected light. To get round this you need to calibrate your system. Adjust the monitor using Adobe's Gamma file which should be located in your control panels directory. This easy-to-follow wizard guides you through adjusting brightness, contrast and gamma to help you get more life-like prints. It's also worth looking out for the scanner and printer profiles which ensure that the file keeps consistent color as it moves through your system.

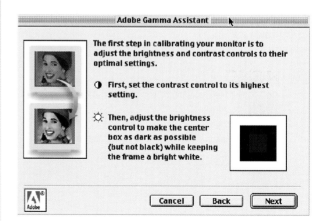

Channels

Each file in Photoshop is made up of channels that store information about the image. A freshly created RGB file has a channel for each of the three colors, and a CMYK has four channels, while Duotones and Index color images have just one.

You can add channels to store info about the picture. For example, Alpha channels can be added to save selections as masks. Then when you want to perform a similar cutout in the future you load the Alpha channel to bring the marching ants into play on the selected layer.

Channels can also be edited individually so you could blend certain ones, or fiddle with the color of just one channel – useful when you want to make a selection based on a certain color which would be easier to do in its own environment.

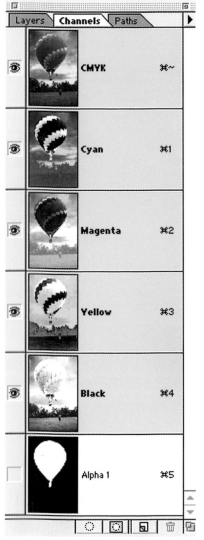

Clipping path

When an image is dropped into an illustration or desktop publishing page the background of the subject will appear on the page too. To avoid this draw around the subject that you want to bring into the design package and save the selection as a path.

When you've finished, save the file as an EPS which keeps all the clipping path data. Now when you place the saved image on the page the background will appear transparent so you can flow text round the subject or drop it onto a different colored panel.

A clipping path was drawn around the swan so it can be dropped into a DTP layout without a background.

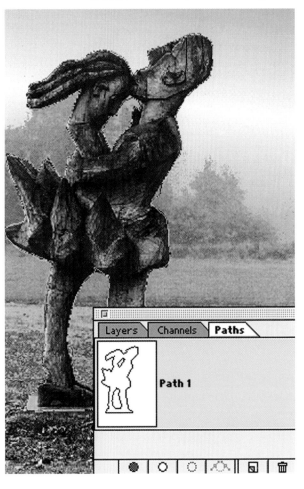

C

Cloning

Where you sample part of an image and place it in another part to duplicate, remove or add detail to an image.
(See Rubber Stamp)

Clouds filter

MENU	FILTER ➜
	RENDER ➜
	CLOUDS

This useful addition to the Filters menu creates cloud effects that can be used as effective backgrounds to your pictures. Before selecting the filter make sure your background color is set to white and the foreground to the color sky you'd like. Blue creates natural skies while orange will deliver a sunset effect and black will produce a stormy sky.

Open a new canvas and set it to the size you want to end up with and select the filter. If you don't like the clouds that are created try again – it's random.

Draw around your subject to make a selection, then copy and paste the selection onto an image created using the Clouds filter. Try experimenting with colors for unusual effects.

Tips

● If the cloud effect is too harsh make the original canvas smaller, apply clouds then increase its size.

● Go to Image➜Adjust➜Hue/Saturation (Ctrl+U), click on Colorize and adjust Hue to change color.

● Use the Gaussian or Motion Blur filter to soften the effect.

CMYK

When a digital image is []t's converted from RGB into CMYK. CMYK is the standard method of printing and uses Cyan, Magenta and Yellow inks to make up the various colors.

A 100% combination of C, M and Y should produce black, but in reality it's a murky brown color so the Black ink (K to avoid confusion with the Blue of RGB) ensures black is printed where necessary.

Collage

Strictly speaking a collage is a collection of photographs mounted together, but Photoshop creates a perfect alternative by bringing several photos together to form one larger image that hasn't seen a drop of glue or sticky tape.

It's a great technique to use to create a family tree, group photo, promo, or surreal image. Using Layers makes the job much easier and more controllable.

Color blend
(See Blending modes)

Color burn
(See Blending modes)

Color cast

Daylight film is designed to produce a natural looking range of colors for outdoor photography or indoor shots taken with flash.

Take a photo indoors without flash and you'll end up with a color cast. This will be green if the light source is fluorescent or orange if it's tungsten light.

Some flashguns are so harsh that they create a blue color cast. The walls in a room can also reflect light to add a color to your subject. Any color cast can be removed, or added, using Photoshop's Color Balance mode.

C

Colorize

MENU IMAGE →
ADJUST →
HUE/SATURATION

Turned on in the Hue/Saturation palette to create a monocolor image. If you want to tone a black & white image first convert it to RGB, Image→Mode→RGB Color. Adjust the Hue slider and watch the image go from blue through the colors of the rainbow and back to blue. Stop when the image is the color you like and save. Use lightness and saturation sliders to vary color further.

Hue: 260, Saturation: 35

Original

Hue: 88, Saturation: 39

Hue: 36, Saturation: 29

Hue: 200, Saturation: 50

Hue: 0, Saturation: 33

Hue: 16, Saturation: 76, Lightness: -11

Hue: 133, Saturation: 53

Hue: 56, Saturation: 69, Lightness: -20

Hue: 310, Saturation: 46

Hue: 0, Saturation: 73, Lightness: 15

C

Color Balance

MENU **IMAGE →**
 ADJUST →
 COLOR BALANCE

QUICK KEY CTRL+B

Used to remove, or create a color cast. The Color Balance palette has three sliders to control the color. Moving the top slider left adds cyan and reduces red. Move it to the right to add red and reduce cyan. The middle slider controls magenta and green and the bottom, yellow and blue. Precise values can be keyed in the top boxes. You can also select where you want the color to change, placing emphasis in the highlights, shadows or midtones. The final option is to Preserve Luminosity which maintains the original brightness when it's turned on.

(See Color Cast on page 26)

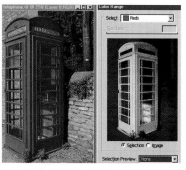

Color Channels
(See Channels)

Color dodge
(See Blending modes)

Color Range

MENU **SELECT →**
 COLOR RANGE

Photoshop's Color Range is a versatile tool to help you select and change the color of a part of your picture. This could easily be a model's lipstick, car paint work or, as in this case, a red telephone box.

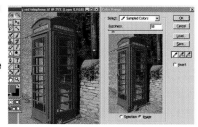

With the picture on a new layer go to call up the Color Range palette. To make it easier to see what you're doing click on Selection at the bottom of the palette to turn the preview window into a grayscale image. For this exercise also make sure Sampled Colors is in the Select menu item at the top of the palette.

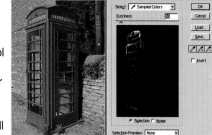

Now click on the left-hand Eye-dropper tool and position your cursor over a part of the phone box and click once. You'll see areas of white appear on the grayscale preview. These are red pixels that are similar in color to the red you've just clicked on.

The Fuzziness slider above the preview window controls the range of reds either side of the one you picked. Adjusting the slider to the right increases the selection, and to the left decreases the selection.

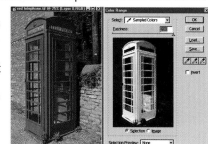

Another method is to let Photoshop pick the color you want to change. Go to the Select menu and pull down the Red option. Now you'll see the Fuzziness scale cannot be adjusted and everything that's red in the image has been selected. You can also use this method to select highlights, midtones or shadows.

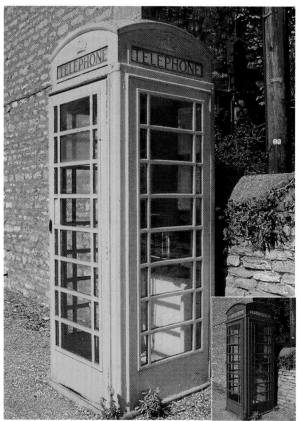

WHICH MASK?

The Color Range palette also lets you choose which type of mask to put over the image as you work. We've been using None, but the menu box, labelled Selection Preview at the bottom of the palette, has four other options.

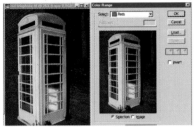

Grayscale makes the image look like the palette's preview.

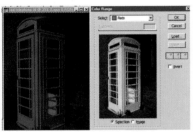

Black Matte makes the unselected area black.

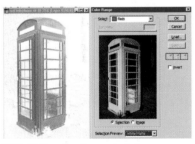

White Matte makes the unselected area... you guessed it, white.

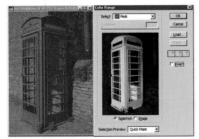

Quick Mask puts red over unselected areas.

Tip
● Press CTRL to change the preview to the image.

Compression

Digital images can have huge file sizes. A 10x8in RGB image with a resolution of 300dpi, for example, has a file size of 21Mb. A few of these will start to fill up your computer's hard disk and a quick calculation finds you'll only even fit 30 on a CD. It doesn't have to be this way. There are several file formats that change the data to reduce the file size – a method known as compression.

Two types exist – Lossy and Lossless. Lossy removes data for good, Lossless keeps it all safe. JPEG is the common storage format used by most digital cameras and Kodak's Picture CD. JPEG is a Lossy version and can affect the picture quality if it's highly compressed.

Contact sheet

MENU **FILE →**
　　　 AUTOMATE →
　　　 CONTACT SHEET

Photoshop has a neat conversion that takes a collection of images and turns them into low resolution thumbnails that are positioned like a contact sheet. It's a good way of keeping a record of your images and also to submit with CDs so the client can have a rough visual of what's included in the package. The quality is a bit disappointing, but it's quick and easy to use.

Tip
● The contact sheet is saved with a white background. If you'd prefer a different color use the Fill tool with a neutral tone selected as the paint and click on the transparent area to deposit the color. Red might clash! Black's a safe choice.

Conditional mode change

MENU **FILE →**
　　　 AUTOMATE →
　　　 CONDITIONAL
　　　 MODE CHANGE

Add this to an action to keep the color mode of a file the same when the action is being performed.

C

Contrast

MENU **IMAGE →**
 ADJUST →
 BRIGHTNESS/
 CONTRAST

The range of tones between black and white, or highlight and shadow.

A high contrast image is one where there's black and white, but not much in between. Shots taken into the sun, or with the sun high in the sky are often high contrast.

A low contrast image is one that doesn't have many tones in the lightest or darkest areas so it looks quite grey and flat. Pictures taken in mist or dull conditions are often low contrast. In the traditional darkroom contrast is controlled using special variable-contrast paper – in the digital lab you just adjust the sliders and watch the preview.

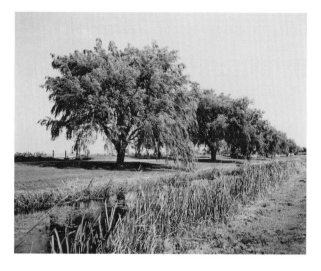

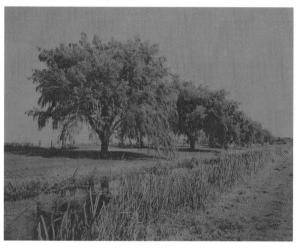

Tip

● You don't have to adjust the contrast of the whole picture. In this example I wanted to brighten the balloon, lighten the grass and darken the sky. Each bit was individually selected and the contrast controls adjusted to suit.

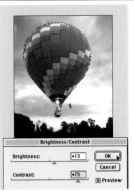

Brightness/Contrast

Brightness: +13 OK
Cancel
Contrast: +75 ☒ Preview

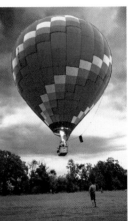

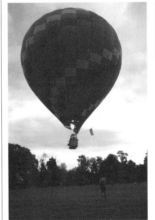

Adjusting contrast in a color image makes colors look dull and subdued when contrast is decrease (above left) or vivid when contrast is increased (right). Edges can become overly enhanced so the result looks very digital.

C

Cropping tool

Use this to be more creative with your composition and cut out wasteful surrounds. Click and hold down the mouse to draw a frame around the subject. Then use the handles to resize or reposition. When you've included

everything you want click in the centre to make anything outside the frame disappear.

Cursor

The cursor is where all the action is. It's the point of the brush, the insertion point, the Cloning source, etc. and is controlled by the mouse or keyboard arrows.

The way it appears can be changed by going to File→ Preference→Displays & Cursors.

Paint cursors can be set to Standard, Precise or Brush Size. The brush or tool icon appears when the cursor is set to Standard, a cross hair appears on Precise and a shape the size of the brush being used appears with Brush size. Which you use is a matter of personal preference and may vary depending on the work you're doing. Try all three in different circumstances and pick whichever works best.

Custom color table

Images produced to be used on the Web need small file sizes. Photoshop reduces the number of colors from millions down to just 256 when it saves files as GIFs and the colors that are used can be saved as a custom table.

Curves

MENU	IMAGE →
	ADJUST →
	CURVES
QUICK KEY	CTRL+M

The Curves palette has a graph with vertical and horizontal scales representing input and output brightness. When you first open this you'll see a straight line running through the graph at 45° from the bottom left to the top right.

The bottom left represents the shadow area, top right is highlights and the mid-point is midtones. You can drag the line by clicking on it and holding down as you move the mouse.

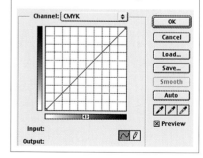

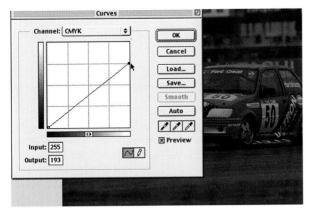

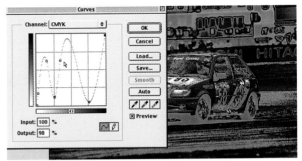

Dragging the top right downwards darkens the picture.

You can also select up to 15 points on the line and pull them in either direction to create snake patterns and very interesting results. This is a mode to experiment with, especially if you enjoy creating surreal effects. If you stumble across a style you like you can save it to reuse on other images at a later date.

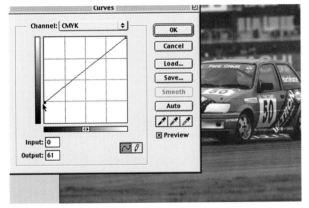

Dragging the bottom left upwards lightens it.

Moving the mid-point up also has a lightening effect and down to darken. These actions can be reversed by clicking on the little arrow on the brightness bar below the graph. Use the Eye-dropper tool and Ctrl+click anywhere on the image and its brightness value will appear as a point on the line. You can then move this point up or down to darken or lighten that part of the image. The picture will look natural, providing you create either a straight line or an arc.

Better black & white

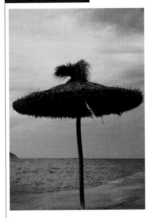

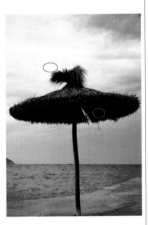

● The Curves feature can be used to enhance your black & white pictures with ease. Simply open up the picture and the Curves palette. Click on the left-hand Eye-dropper tool and, using your mouse cursor, place the Eye-dropper icon on the darkest part of the image and click. Do the same with the right-hand Eye-dropper on the brightest area and click to produce an image with a more satisfactory tonal range.

Tip

● Create bizarre effects by saving a gradient as a Map Setting and then load that as a Curve. Double click on the Gradient tool. Then click on Edit in the Gradient tool palette. Select a bright gradient such as Rainbow and hold the Ctrl key down while clicking on the Save button. This will create a Map Setting file (*.AMP).

Go back to the Curves palette and click Load. From Files of Type: select the Map Setting option and locate the gradient that you've saved. You're picture will burst into a rainbow of colors.

De-interlace filter

A filter used to smooth moving images captured on video.

Defringe

MENU	LAYER →
	MATTING →
	DEFRINGE

No matter how hard you try, when cutting round a subject you usually leave a few pixels from the old background. When you paste the cutout to the new background the unwanted pixels may stick out like a sore thumb. This yellow flower, for example, cut out from a green background has a few green pixels around the edge that show up when it's pasted to its new red background.

The Defringe command changes these green pixels to yellow to produce a cleaner effect. Like most commands, you can enter a pixel value, in this case, a width of between one and 64 pixels, depending on the nature of your original selection.

Desaturation

MENU	IMAGE →
	ADJUST →
	DESATURATE
QUICK KEY	SHIFT+CTRL+U

This mode takes all the color out of an RGB image, changing it to black & white without you having to convert it to grayscale. You can also produce this by dragging the Saturation slider to the left in the Hue/Saturation mode.

Despeckle filter
(See Noise filter)

Deselect

MENU	SELECT →	Removes 'marching
	DESELECT	ants' selection from
QUICK KEY	SHIFT+D	the image.

Difference mode
(See Blending modes)

Dissolve mode
(See Blending modes)

Distortion filter

MENU	FILTER →
	DISTORT

A collection of filters that distort the image. If you have an older computer be patient, some of these filters are very memory intensive and apply to your image at a snail's pace.

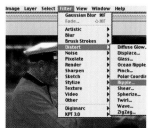

DIFFUSE GLOW

Creates an effect similar to looking through a soft diffusion filter by adding see-through white noise to the image and a glow, fading from the centre of the selection. Can be used to simulate infrared film effects. The palette has sliders to control the graininess, amount of glow and clear amount.

DISPLACE

Changes the image into a pattern that's previously been saved as a Displacement Map. These can be created from your own images or you can use one of the 12 supplied in the Displacement Maps folder within the Plug-Ins folder of Photoshop 5. These include Tiles, Streaks and Honeycomb.

The palette has options to tile a Displacement Map that's too small for the image you're applying it to or stretch it to fit. A tiled Map is the same image repeated to fit to the edges. The stretched version creates interesting effects and can be varied by changing the percentages in the horizontal and vertical scales.

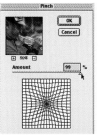

GLASS

Applies a distorted effect that looks like the view through a bathroom window. There's a choice of four styles and others can be created and loaded manually.

The palette has sliders to control the distortion level, smoothness and scale which can then be viewed in the preview window.

PINCH

A slider that varies from –100 to +100 to make the centre of the image appear to expand like a balloon or squeeze in like an hour glass.

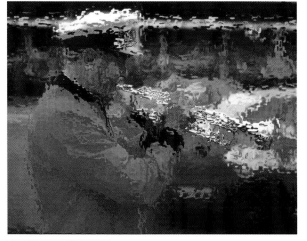

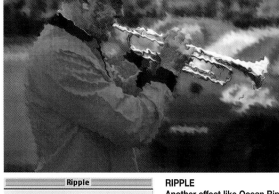

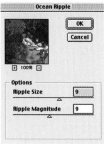

OCEAN RIPPLE

Similar effect to the Glass filter, offering two sliders to control ripple size and magnitude.

RIPPLE

Another effect like Ocean Ripple that creates a water pattern on the selected area.

The slider controls the amount of ripple and a pull down menu has three ripple sizes.

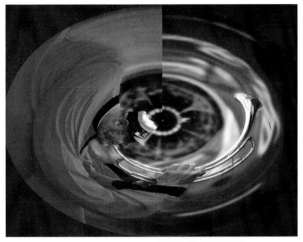

POLAR COORDINATES

Unusual effect with two options to convert the image from either rectangular to polar coordinates or vice versa. Can be used with text to stretch it round an image, or combined with a few other filters to create strange backgrounds.

SPHERIZE

In Normal mode it produces a similar effect to Pinch. In Horizontal Only the image becomes thinner or thicker as you adjust the slider and in Vertical Only it becomes shorter or taller.

SHEAR

Displays a grid and a straight vertical line that you pull around to make a curved shape. This shape transfers to the selected image, distorting it along the curve.

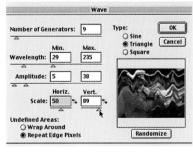

WAVE

An advanced version of the Ripple filter with seven slider and five buttons to choose from that control the number of wave generators, the distance between waves, the height and the type. Experiment at your leisure or press the Randomize button and let it choose a value.

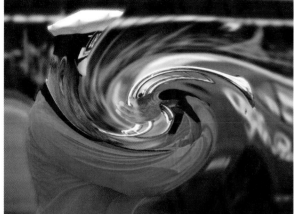

Document Size

Click on the small arrow in the bottom left-hand corner of the image to show a five line menu. One option is Document Size that displays two values. The first is the size of the file if it's flattened to remove Layers data. The second is the value including Layers data and Channels.

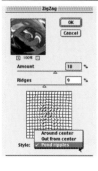

TWIRL
Creates a spiral effect similar to the way water goes down a plug hole. It works in a clockwise or anti-clockwise direction depending on where the slider is set.

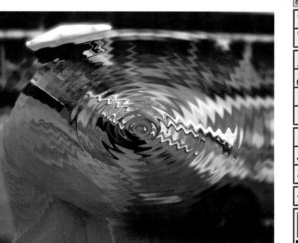

Dodge tool

Works like the darkroom dodging device. Hold the paddle over your image and the areas it covers will become lighter.

The palette's options includes a menu to set for dodging midtones, highlights or shadows, along with an opacity setting to vary the strength of the dodging effect.

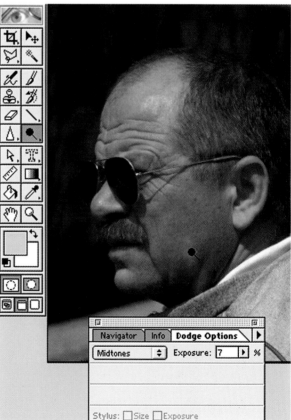

ZIGZAG
Another Ripple style distortion but one that includes the realistic Pond Ripple option. Apply this to water and it will look just like you've thrown a pebble in before taking the photograph.

Dots per inch (DPI)

The measurement used to determine printer and monitor resolution. A 200dpi printout means there are 200 dots in every inch. A monitor resolution with 96dpi is better than a 72dpi one, and so on.

Drop shadow

MENU LAYER → Photoshop
 EFFECTS → 5 makes
 DROP SHADOW creating
drop shadows a doddle. All
you do is make a selection, go
to the filter and apply the shadow. From the palette menu you can choose the Blend mode, opacity, angle, distance, blur and intensity – play around until you're happy with the results.

Duotone mode
(See over the page)

Duplicating images

MENU IMAGE → Opens up an identical copy of the image
 DUPLICATE and keeps the original open. You can also
use the drag & drop method to duplicate one image onto another and avoid using up any RAM. Just click on the image you want to copy, hold down the mouse and drag the cursor over to the destination canvas. If, as in this example, you drag a color image onto a black & white one it will be automatically converted.

Duplicating layers

MENU LAYER → Adding a duplicate layer in the same image
 DUPLICATE LAYER is useful when you want to produce
complex multi-layered images using Blend modes. Layers can also be duplicated from one image into another using the same drag & drop technique, as described in duplicating images, or copied and pasted.

Tip
● Hold down the Alt key as you duplicate the image to add 'copy' automatically to the end of the title.

d

Duotone mode

MENU IMAGE →
 MODE →
 DUOTONE

Grayscale images display up to 256 shades of grey, but a printing press only reproduces around 50 levels per ink. Grayscale images printed with black ink look coarser than ones printed with two or more inks.

Duotones are images with two colors that increase the tonal range of a grayscale image and look stunning when subtly applied. When black is used for shadows and grey for midtones and highlights you produce a black & white image. Versions printed using a colored ink for the highlights produce an image with a slight tint that significantly increases its dynamic range.

You need to be in grayscale mode before you can enter the world of Duotones (Image→Mode→Grayscale). Choose a Duotone pre-set by clicking on Load and locate it in the Goodies folder (all the examples here are supplied pre-sets), or create your own color by clicking on the colored ink squares to call up the color wheel.

Select a color you like and watch the bar at the base of the palette appear as a range of hues from black to white.

You can also select Monotones, Tritones and Quadtones from this menu. If you stumble across a Duotone color effect you'd like to keep click on save and put the *.ado file in a folder. It can then be called up from the Load option when required.

You can edit the duotone curve by clicking on it to bring up a new dialogue box. Moving the curve right makes colors print heavier in the shadows while moving it to the left makes colors print lighter in highlights.

Dust & Scratches filter
(See Noise filter)

Original grayscale image

Pantone duotone 144 orange (25%) bl2

Pantone duotone 159 dark orange bl1

Pantone duotone 327 aqua (50%) bl3

Pantone duotone 478 brown (100%) bl2

Pantone duotone 507 burgundy (75%) bl1

Pantone duotone 527 purple (100%) bl2

Pantone duotone blue 72 (25%) bl1

Pantone
duotone
blue 286
bl1

Process tritone
BCY green 1

Pantone quadtones
bl 430 495 557

Pantone
duotone
brown 464
bl2

Process tritone
BMC blue 1

Pantone quadtones
bl 431 492 556

Pantone
duotone
green 3405
bl1

Process tritone
BMY brown 1

Pantone quadtones
bl 541 513 5773

Pantone
duotone
green 349
bl1

Process tritone
BMY red 1

Pantone quadtones
bl 75% 50% 25%

e

abcde**f**ghijklmnopqrstuvwxyz

Edges
Eraser
Exporting files
Exposure correction
Extract
Eye-dropper

Edges

An edge is formed where adjacent pixels have high contrasting values. Photoshop has a number of filters that detect these and apply contrast reducing or increasing effects to soften or sharpen the image accordingly.

The top half of the picture (left) is an enlarged part of the stem of the plant in the picture above.
The Find Edges filter picks up all the areas of edge contrast and produces an almost posterized version that highlights these edges.

Emboss filter
(See Stylize filters)

Eraser

Use this to remove pixels, replacing them with the background color, or to a previous state using the Erase to History option, or to an underlying layer.

The Eraser options palette lets you select the opacity of the Eraser and can be set to gradually fade out in a selected number of steps.

You can choose from four brush styles including Paintbrush, Airbrush, Pencil and Block and also vary the size of these from the Brush options box.

The Paintbrush has a Wet Edges option that produces a stronger effect towards the edges of the brush stroke.

Exporting files

MENU FILE → Photoshop comes
EXPORT with two plug-in modules to export files to GIFs or Paths to Adobe Illustrator. Paths to Illustrator converts Photoshop paths created with the Pen tool into Illustrator files.

Tip

● Shift+E rotates through the varies brush options.

Exclusion mode
(See Blending modes)

Exposure correction

When an image is too dark or too light, caused by either poor scanning or a badly exposed original, it can be corrected using several Photoshop features.
(See Levels, Curves and Brightness)

Auto Levels have been applied to brighten up the right-hand side of this image that was scanned in using the scanner's auto settings.

e

Extract

MENU **IMAGE →** **EXTRACT** This new feature of Photoshop 5.5 makes selecting objects from their background much easier and is especially useful on complex cutouts such as hair. You first draw around the edge that you want to cut out using the Edge Highlight tool. Then fill the inner area with the Fill tool. When you click 'preview' the command goes to work and produces a foreground cut out on a transparent background. If you're happy with the preview cutout click on OK and the extraction is applied.

Cutting round the hair on this photo could be really difficult to do using one of the normal Selection tools.

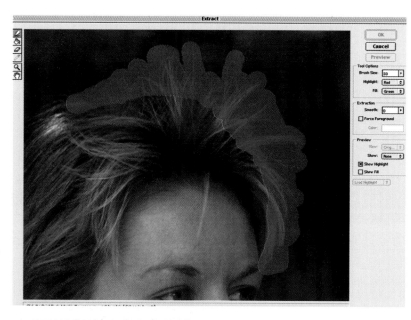

Paint over the edge that you want to cut round ensuring foreground and background areas are both covered by the highlighter.

Above left: Use a larger sized highlight brush to paint over areas that aren't easy to define such as the hair where fine strands appear.

Above right: Then select a smaller size brush for the definite edges such as this girl's face and shoulders.

Left: When the selection is complete click on preview to see the extraction take place. Depending on the speed of your computer's processor and the size of the image this could take a few minutes, or longer, to perform the task.

Right: If you're happy, click extract to produce the cutout image with transparent background.

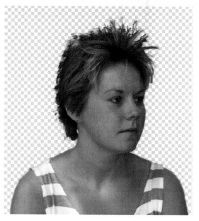

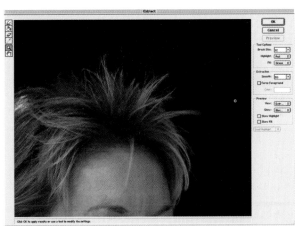

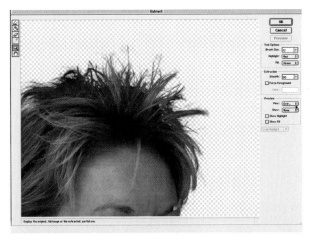

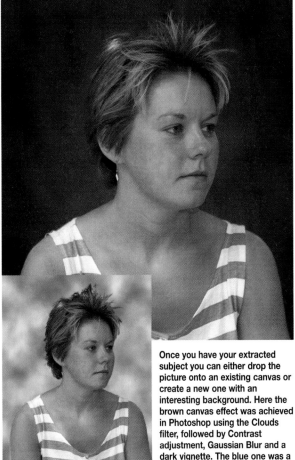

Once you have your extracted subject you can either drop the picture onto an existing canvas or create a new one with an interesting background. Here the brown canvas effect was achieved in Photoshop using the Clouds filter, followed by Contrast adjustment, Gaussian Blur and a dark vignette. The blue one was a straight Clouds filter shot with Gaussian Blur. You could also use one of your own photos as a ready-made background.

The extracted image can be viewed in a number of ways. The pre-set version is with a transparent background (above left), but you can also select grey or black (above) which is more useful in this example to see how good the cutout is.

> **Tip**
> ● Some areas of the image that you wanted to keep may have been erased. If this happens set the History brush on to the stage prior to the extraction and paint back the missing pixels.

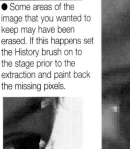

Eye-dropper

This tool, located on the tool palette, is normally used to select the foreground or background color and the only control you have is selecting the sampling area which can be accurate to one pixel, 3x3 or 5x5. Simply position the dropper end over the area you want to sample and click the mouse to take the sample which becomes the foreground color.

Holding down the Alt key when you click selects the background color.

The Eye-dropper also appears in several other palettes, including Replace Color, Color Range, Levels, Curves and Hue/Saturation.

> **Tip**
> ● Holding down the Alt key while using the Airbrush converts it into the Eye-dropper.

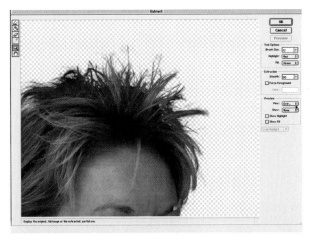

Fade command

MENU **FILTER →** Used immediately after

 FADE you've applied a filter

to an image, to vary the strength of the filter's effect in relation to the original image. You can also select the Blend mode making the filter appear as though it's on a separate layer.

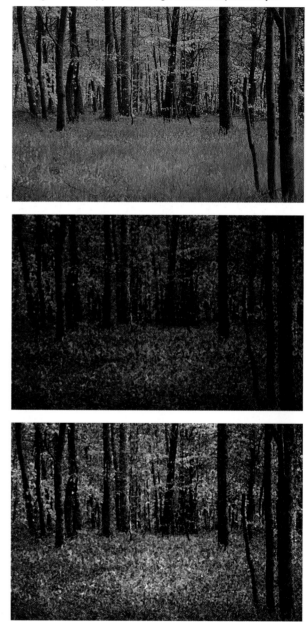

The Fresco effect from the Artistic filter menu has created a moody oil painting (middle). The Fade command, set to Luminosity Blend mode, gives added sparkle in the greens which is further enhanced by increasing brightness and contrast (bottom).

Feathering

Useful feature that's used to soften the edge of a selection
before you cut out or add a filter effect. You control the pixel
width of feather from the selection area inwards and outwards.
The result is a gradual softening rather than a harsh edge.

A small feather of one or two pixels is all that's need to make
a cutout appear less obvious when pasted on a new
background. A large feather of around 30 is better when you're
adjusting the brightness, contrast or color of a selection within
an image. As with most features it's best to try several settings
before committing the image to disk.

**Feathering is useful to make a graduated sky. In this example I've applied
−35 brightness +25 contrast to a non-feathered selection (right), to one with
a +20 feather (below) and the best has a 100 feather (below right).**

File conversion

Photoshop files can
be converted into
other formats
suitable for different
uses. When you
save an image,
select File→Save As
and pull down the
Save As menu bar in
the palette to see a
list of file formats to
choose from.Then
drag the cursor over
the one you want to
save in that format.
Help screens will
appear where
necessary.

File info

MENU FILE → A dialogue box with
FILE INFO several sheets. The
first has spaces to add a picture caption,
headline and special instructions that
can be saved and used on future
projects. The second has room to enter
key words. Next is the category file,
then credits, copyright option and
contact details. Each one can be
accessed by Caps+1, Caps+2, etc.

f

File size

Is the physical size of the file, measured in kilobytes (K) or megabytes (Mb), that appears at the bottom left of your image. The larger and more complex an image the bigger its file will be. As an example, a simple 4x6in grayscale image, saved at 175dpi, has a file size of around 700K. The same file saved as an RGB increases to just over 2Mb and as a CMYK image to nearly 3Mb. A 300dpi 10x8in image suitable for magazine repro is 27.5Mb. Start adding Layers, or a History palette, and the file could quadruple in size.

Filling color

Works like the Bucket tool and drops color into the selection. Choose to fill using the foreground or background color in the palette. You can also adjust opacity and select a Blend mode to vary the result.

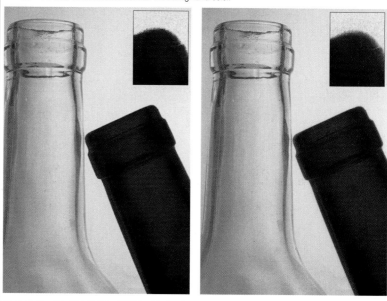

49

Flatten image

MENU LAYER ➔ FLATTEN IMAGE Images with individual layers can only be saved in the Photoshop PSD file format and need to be merged (flattened) if you want an alternative format. Merging layers reduces the size of the file so it's worth doing if you're totally happy with your results.

In this example eleven layers are used which result in a 25Mb image (above). When merged the file size becomes just 5.72Mb (below).

Tip
● If you want to keep the image with layers but need a version in another file format, choose File➔Save a Copy to create a flattened duplicate.

Foreground color

The foreground color is used to paint, fill and stroke selections and appears as the upper square in the toolbox. You can change the color by either sampling from an image using the Eye-dropper, clicking on the colored square to call up the color picker, or choosing Window➔ Show color to bring up the Color palette.

Freehand Pen tool
(See Pen tools)

Fuzziness setting

A similar feature to Tolerance that determines how many colors are selected by the Eye-dropper tool in the Color Range mode. Sliding the control to the right increases the fuzziness and allows a larger range of colors to be picked.

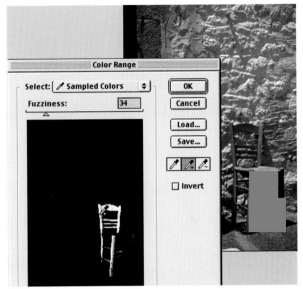

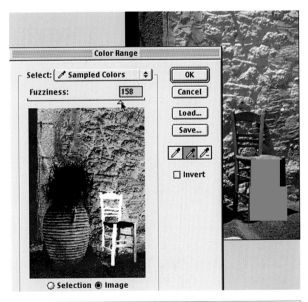

Tips
● Avoid high fuzziness levels – they create blurred edges and settings too low can cause jagged edges and missing selected pixels.
● Keep your finger held down on the mouse button as you move around the preview image with the Eye-dropper icon. This will continually adjust the selection.

g

Gamut warning

MENU	VIEW →
	GAMUT WARNING
QUICK KEYS	SHIFT+CTRL+Y

The range of colors a computer monitor can display is known as the gamut and the monitor's gamut has a larger range of colors than a printer can output. If you don't watch out the vivid colors you've been editing will appear from the printer looking dull and lifeless. The Gamut warning's job is to prevent disappointment when you work in RGB mode. It does so by highlighting all the pixels that are out of gamut so you can modify the color before printing. Go to File→ Preferences→ Transparency & Gamut to adjust the way the warning works.

A small exclamation mark also appears above the color in the Color Picker and Color palette when a color is out of the printer's gamut.

Gaussian Blur
(See Blur filter)

GIF format

A GIF (Graphics Interchange Format) is an image with a reduced palette of 256 colors or less that's ideal for viewing on the Web. Photoshop files can be converted to GIFs using File→Save As, File→Export or from within Adobe's Image Ready program which is now supplied as part of Photoshop 5.5. GIFs can be saved as normal or interlaced versions that appear gradually on screen as they download from the Web.

Glass filter
(See Distortion filter)

Glow effect

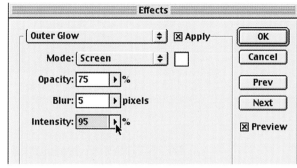

MENU **LAYER →**
EFFECTS →
OUTER/INNER
GLOW

A glow effect looks particularly effective when produced around type and can be made to appear from inside or outside the selection in any color. The mode is great for creating fancy head lines for Web sites or newsletters

Effects

| Outer Glow | ⊠ Apply | OK |

Mode: Screen
Opacity: 75 %
Blur: 5 pixels
Intensity: 95 %

Cancel
Prev
Next
⊠ Preview

You can also control the opacity, blur and intensity of the glow along with the Blend mode from within the Effects palette.

Gradient Mask

MENU **LAYER →**
ADD LAYER MASK

Adding a Gradient Mask to a layer makes the image take on the gradient when blending with other layers. This is useful for complex image creation.

| Layers | Channels | Paths | ▶ |

Normal — Opacity: 100 %
☐ Preserve Transparency

👁 Layer 1 copy

👁 Layer 0

g

Gradient tool

Interesting skies, colorful backgrounds and rainbows are all easily created by selecting the Gradient icon from the toolbox.

Click and drag the tool box icon to select one of five gradient patterns that include Linear, Radial, Angular, Reflected and Diamond – each designed to create a smooth blend from one color to another. Double clicking on the icon brings up the dialogue box where the gradient effect can be edited. As with many Photoshop palettes you can adjust the opacity and the Blend mode to control the effect the gradient has on the base image. There's also a selection of pre-set color gradients to choose from, or you can edit your own.

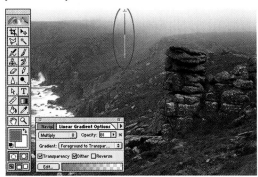

To create the Gradient Fill just click on the image at the desired start point, drag to the end point and release to flood the image with color.

If you don't like the effect Undo (Ctrl+Z) and start again.

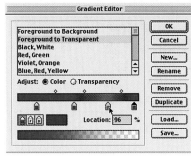

To edit a Gradient click Edit, select one of the pre-sets and adjust the sliders at the base of the palette until you have a result you're happy with. Then Save.

Tips

● Ticking the Dither box prevents any banding in the gradation.
● The Gradient tool doesn't work on Bitmap or Index color images.

Grain

Film-like grain can be added to pictures using either the Noise filter or the Diffuse Glow with the Glow slider turned down and Grain increased. You could also try creating your own grain pattern and adding it as a layer using a Blend mode.

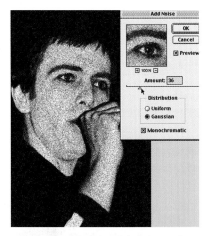

53

Grayscale mode

Produces an image made up of 256 grey tones from black to white. You can't adjust Hue or Saturation in this mode, but Brightness and Contrast can be controlled. Use this mode to convert original color images to black & white.

Grid

MENU	**VIEW →**
	SHOW/HIDE GRID
QUICK KEY Ctrl+'	

A non-printing grid of horizontal and vertical lines that's used to arrange elements symmetrically within an image and to straighten up sections, making it perfect for use with the Transform→Perspective feature.

Selections snap to the grid so it's easier to create and align the same sized boxes.

Tip

● Select View→Snap To Grid and the painting tools will follow the grid making it easy to paint in straight lines.

Guides

MENU	**VIEW →**
	SHOW/HIDE GUIDES
QUICK KEY Ctrl+;	

These are horizontal or vertical lines that can be pulled out from the edge rulers to appear over the image. If the rulers aren't visible go to View→Show Rulers.

Guides can be used to align text or for laying out parts of the image in a symmetrical pattern. Go to Preferences→Guides & Grid to choose the guides' color and style (straight or dotted line). The guides will not print and can be removed or repositioned using the Pointer tool.

As with the Grid, Paint tools will snap to the guides if the Snap to Guides option is selected from the View menu.

Highlights
Histogram
History brush
History palette
Hue

Hard light
(See Blending modes)

Highlights

The brightest parts of the image with detail that will still print. These can be adjusted using the clear triangle on the slider control that appears on the right-hand side of the Levels graph.

Histogram

MENU **IMAGE →** A graph that
 HISTOGRAM plots the image in a series of pixel values from 0 (black) to 255 (white) and looks like a mountain range profile.

The horizontal scale represents shadow to highlight detail and the vertical axis is the number of pixels at a particular point. You can view the histogram of each of the RGB channels individually or as a group. It's used to check whether your image is suitable for printing and can be edited in the Levels palette by adjusting highlight, shadow and midtone sliders.

A low key image appears with most of the peaks concentrated in the shadow area at the left-hand side.

A high key image has the peaks in the highlight area to the right.

The average tone image should have a graph that rises from the far left, peaks across the middle section and falls to the far right.

History brush

Use this to paint in details from a previous stage of editing. Click on the box that appears in the History palette at the stage in the image editing process that you'd like to apply and paint onto the new level.

This is a great option if you're considering hand-coloring a black & white image. Cheat by starting off with a color image and convert it first to grayscale to discard all color information and then back to color. The black & white image can then be colored using the History brush. Click on the left of the opening image to turn on the History brush icon. Then click on the latest stage and begin to paint.

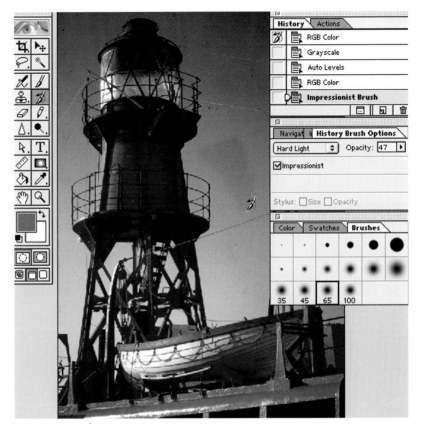

Tip

● Set the brush opacity to around 50%, turn the Impressionist feature on and brush erratically over the image for a surrealistic watercolor wash.

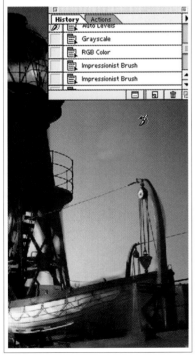

History palette

Every task you perform in Photoshop 5 is recorded as a step, or state, in the History palette. This allows you to go back up to 100 previous stages when an image you're working on starts to go wrong. A slider on the left-hand side can be dragged slowly through the stages to help you find when things start to go wrong. Simply click on the last stage that you were happy with and start again to change history – if it were just that simple in life!

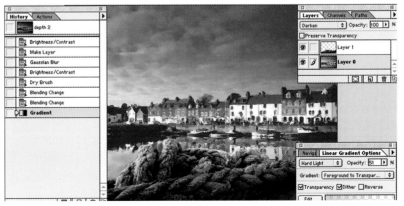

h

Hue

MENU **IMAGE →**

ADJUST →

HUE/

SATURATION

Hue is the image color and varying the Hue slider changes the overall color. The scale runs through the colors of the rainbow starting at the left with blue.

 This picture of fishing nets shows the effect the Hue slider has over the color when adjusted in 30 unit increments.

Hue: 0 (Original)

Hue: +180

Hue: +150

Hue: +60

Hue: +30

Hue: -90

Hue: -120

Edit: Master

Hue: +25

Saturation: 0

OK
Cancel
Load...

Hue: +120

Hue: +90

Hue: -30

Hue: -60

Hue: -150

Hue: -180

Image resolution

The measure of digital image quality, usually in pixels per inch (ppi). The more pixels per inch the higher the resolution. Lens quality also affects overall image quality.

The resolution only needs to be as good as the viewing media. If, for example, you're only ever going to look at the images on a computer monitor you only need a resolution of 72dpi for Macs and 96dpi for a PC. If, on the other hand, you're wanting to send the images to a magazine or book publisher you'll need a resolution of at least 300dpi. Most desktop inkjet printers require between 150 and 240dpi files.

Indexed colors

Color mode used to reduce the image to 8-bit to suit viewing on older monitors or on the Web to keep the file size conveniently small.

Several color palettes can be selected from the menu including a Web palette with 256 colors that's widely used by Web browsers so your image will look the same whichever computer platform or Internet explorer the picture is viewed on.

Two pictures of trees A and B. A is the original 16.7 million color image. B is index color with just 256 colors. At a glance they look similar. Enlarge just a small portion of the image and you'll see the lack of smooth gradation between colored pixels.

256 colors is fine for Web use, but when making prints stick with maximum color depth.

Input

Inputting pictures into the computer can be done in a number of ways. The fully digital route is to use a digital camera which can be connected to the serial port, or more recently the USB port.

Alternatively the memory card can be taken out of the camera and slotted into a card reader that's like a small drive connected to the parallel or USB port. Some of the latest cameras even have infrared transmission.

If you have a traditional camera and shoot negative film or transparencies you can buy a film scanner that converts the film image into a digital file and connects to the computer's SCSI, USB or parallel port.

A flatbed scanner is like a mini photocopier, designed to scan flat artwork such as prints. They're available to fit in USB, parallel or SCSI ports.

Another option is to have the films scanned by a lab. Many shops now offer Kodak's Picture CD service where the films are processed as normal but you also get a CD with the images. **(See Picture CD)**

Finally you could have a shop scan your photos and place them on a Web server that looks after your images. You can then log on the site and download the pictures you want to print.

Info palette

MENU **WINDOW →** Basic **SHOW INFO** palette that displays RGB and CMYK information for the image being worked on. Moving any tool across the image will change the value on screen as it passes over each pixel. The palette also shows X and Y co-ordinates and the width and height of any box or rectangular section that you create.

Interpolation

If you change the size of a digital file your software either adds pixels when increasing the size or removes them when making the image smaller. This is known as Interpolation and relies on Photoshop knowing which pixels to add or dump.

There are three methods of interpolation – Nearest Neighbour, Bilinear and Bicubic. One can be set as default by going to File→Preferences→General.

Nearest Neighbour offers the fastest method by copying the adjacent pixels, but results are often poor. Bilinear looks at pixels above and below plus left and right and averages out the result to give an intermediate pixel and a smooth blend. It's slower than Nearest Neighbour, but not as slow as Bicubic which looks at all the pixels surrounding each pixel and averages them all out to create the new ones. It then boosts contrast between each pixel to reduce softness.

This photo of an eye is 29 pixels wide by 29 pixels high. Increasing the image to create a 290x290 version requires a hefty interpolation job, and it's a good test for the various methods. A: Near Neighbour, B: Bilinear, and C: Bicubic.

i / j

Inverse

MENU	SELECT →
	INVERSE

When the subject is difficult to draw round accurately, look at the background or surrounding pixels. Could Color Range be used, or the Magic Wand? If so, select the surrounding areas and then the Inverse command to swap to the subject.

Inverting

MENU	IMAGE →
	ADJUST →
	INVERT
QUICK KEYS	CTRL+I

Changes a color negative image into a positive and vice versa.

As a negative you can still apply other filter effects – this example is Find Edges followed by Fade Find Edges at 100% with Difference blend selected.

JPEG

Short for Joint Photographic Experts Group. The most popular method of image compression that's great for continuous tone photographs.

It supports CMYK, RGB and grayscale. It's a lossy compression method so information is discarded to save disk space, but when saved at a minimal compression level the image can be indistinguishable from the original.

The JPEG Options palette has a slider to adjust the compression level from 0 low quality/high compression to 10 high quality/low compression.

You also have three format options – Baseline Standard for normal use, Baseline Optimized, a higher compression method used for saving images for Web use, and Progressive also for Web use. This option displays the image in stages so the viewer can skip by if the photo isn't interesting.

This sign shows the effect of JPEG compression. The original uncompressed file has a file size of 2Mb. Watch what happens to the file size and the quality as higher compression is chosen.

Cropped version of original.

JPEG, maximum quality, setting 10, file size 1.1Mb. It's hard to spot any difference with this and the uncompressed file.

JPEG, high quality, setting 7, file size 392K. Very subtle changes in color of some pixels, but still very good.

JPEG, medium quality, setting 4, file size 228K. It's now starting to clump groups of pixels in blocks noticeable in the outlined area.

JPEG, low quality, setting 0, file size 104K. Low quality produces poor results and the recognizable problems of heavy compression.

Warning

● Every time you close and reopen a JPEG file you compress and uncompress, and the affect can be cumulative so the image may gradually decrease in quality. Work in PSD format until you've done everything you want to the image then save to JPEG.

Joiner

A traditional photo technique is to take a series of pictures from the same position but with a different viewpoint for each. Then the photographer would mount the images side by side to create a 'joiner', or

panorama. This can be done automatically digitally using software such as Stitch or PhotoVista.

1 Select a series of pictures that have been taken for the panorama.

Click [Arrange] and specify the merge order.
Drag the images into the correct order.
Finish by clicking the [Merge All] button

2 Import them into a program such as PhotoStitch.

3 Let the software automatically stitch them together. You may then have to crop and clone in the blank spots.

4 The result is an impressive panorama.

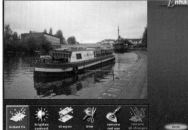

Keyboard shortcuts

Shortcuts to commands and options using individual or groups of keys. Learn the ones you use regularly to speed up your work. When shortcuts are available

they're listed in this book as Quick Keys.

Kodak Photo CD

Kodak were way ahead of their time launching

Photo CD in 1992 as a product designed to view photos on a television. Unfortunately it didn't take off until around four years later.

The service is offered by photo finishers and pro bureaux. Your images are scanned at high resolution using drum scan quality and recorded onto disk as Pict files. When you open the disk you have a choice of five file sizes from 192x128ppi to 3072x2048ppi. The smaller sizes are for using as positionals or for TV and Web use and the larger files are for making prints allowing up to around 7x10in enlargements.

Kodak Picture CD

Similar principle to Photo CD, but with a magazine style interface and free software, produced in association with Adobe and Intel. The CD opens up with a contents page and a range of options. Various menus let you edit and enhance your pictures, send them as e-mail postcards, catalogue them and print them. The service is available when

you have a film processed and just requires a tick on the film processing envelope to ensure the lab produces a Picture CD of your film as well as a set of photographs.

The interface is extremely friendly and easy to navigate. The first page that appears on screen is the cover of the magazine (above). Clicking the arrow at the bottom takes you to a contents page (left). This lists various options on the CD and your pictures appear on the right with brief captions. Selected pictures can be enhanced using free software (below left) and the print option lets you select single or multiple images to print at various sizes (below right).

Lab Color

An international standard for color measurements developed by the Commission Internationale de L'Eclairage (CIE). It's capable of reproducing all the colors of RGB and CMYK and uses three channels – one for luminosity and the other two for RGB type color ranges.

Some users prefer to work in this mode as it's device independent and colors that fall into the CMYK gamut aren't changed when you convert to CMYK.

Lasso

There are three Lassos to pick from the toolbox.

The two standard versions, Freehand and Polygon, have been joined by a Magnetic version.

The Freehand Lasso is used in most programs and is used by accurately drawing round the subject. You can select a feather to be applied to the section and turn anti-aliasing on or off.

The Polygon Lasso is good for drawing round boxes and straight edged items as it creates a straight edge between the source and destination point.

Magnetic Lasso is arguably the most useful Lasso. You draw roughly around the subject and the Lasso detects contrast changes and defines the edge. It then pulls the inaccurate drawing in to line, often creating a very good selection.

Tip

● Don't worry too much about being spot on with your drawing. You can hold down the Shift key to add to the selection or the Alt key to take away from it.

Layers

MENU **LAYER →**
 NEW LAYER →
QUICK KEY **SHIFT+CTRL+N**
One of the most useful features of Photoshop is Layers. Basically, using layers is like having several sheets of tracing paper, each holding part of the image. Laying the sheets on top of each other builds up the image and it's easy to remove any sheet to change the feel of the work. But, being digital, layers offer much more.

You can change how one layer reacts with another using the Blend modes (see individual entries). You can adjust the opacity so one layer is stronger than another, you can apply a filter effect to one layer and you can copy and paste from one layer to another.

The Preserve transparency option can be turned on or off in Layers. When on, any transparent areas will not be affected by Paint tools.

This leaf image has four layers, combined using Blend modes.

Layers are like sheets of glass or tracing paper each one placed on top of the other to produce a combined multi-layer image.

Layer Mask

MENU **LAYER →**
 ADD LAYER MASK
A layer mask controls how much of that particular layer appears in the overall image. Black masked areas don't show through and white areas do. You can use the vignette and graduate filters to good effect using Layer Masks.

Masks can be turned off at any stage and any bits of the image that have been masked will show through on the overall image again.

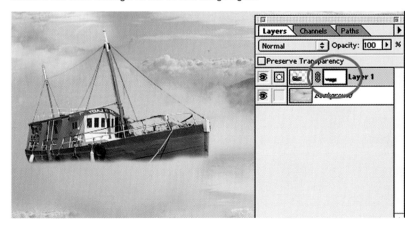

Above left: The boat has been cut out and pasted on the sky layer, and it looks like it has!
Left: By adding a Layer Mask you can paint out areas of the boat using the Eraser.
Above: Or paint them back in using the Airbrush.
Below: Okay, this one's not the most stunning creation, but you get the idea!

Lens Flare

MENU FILTER →
 RENDER →
 LENS FLARE

Another one of those filters that will make lens manufacturers cringe. They spend millions on research to get a lens that you can point into the light without getting flare and then you go and stick some in using Photoshop! The truth is a touch of flare can sometimes add the extra bit that's needed to make the image work.

The palette offers a choice of three lens types and an adjustable brightness control. There's a preview window to check the result before you apply the effect to the main image.

105mm prime

Levels

MENU IMAGE →
 ADJUST →
 LEVELS
QUICK KEY Ctrl+L

Used to adjust the black and white points of an image to change the contrast. When you're in this palette there's a window with the histogram and sliders to control the darkest and lightest points. The left-hand triangle controls the shadow area, the right triangle looks after the highlights and the middle triangle adjusts midtones.

The original scan is far too dark. This can be resolved in Levels by adjusting the highlight and shadow area markers to improve the dull scan.

50-300mm zoom

35mm prime

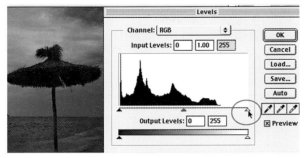

The white point is way beyond the histogram.

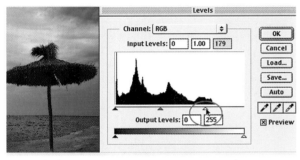

Go into Levels and adjust brightest to lighten the image.

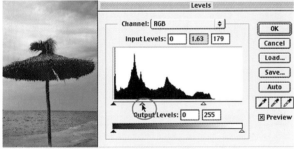

Adjust the mid-point.

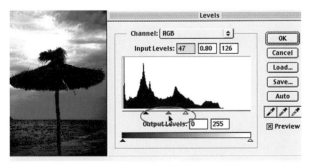

You can make posterized effects too.

Lighten mode
(See Blend modes)

Lighting effects
(See over page)

Line art

An image that's drawn using one color on a background color with no midtones. Line art is a popular giveaway on royalty-free CDs, such as this example, taken from IMSI's Masterclips collection – should that be Lion Art!

Line tool

Used to place lines in the image. When you draw with the Line tool it uses the foreground color and whatever width is set in the palette. You can change the color, width and style of line from the Options palette. You can also stick on an arrowhead making the tool useful for creating pointers.

Luminosity blend
(See Blend modes)

LZW compression

A lossless method of compression used with with TIFF and GIF file formats to save space without affecting image quality.

The disadvantage is it takes longer to open a compressed image than an uncompressed version.

As a matter of fact

● LZW is named after its three inventors Abraham Lempel, Jacob Ziv and Terry Welch. Sounds too odd to be true!

Lighting Effects

MENU **FILTER →**
RENDER →
LIGHTING EFFECTS A superb range of
filters that can be
used to simulate
various forms of light from spotlight to
tungsten. There's plenty to go at so it's
a case of picking a suitable image and
sliding the controls to experiment.
Remember to select undo (Ctrl+U) if you
don't like the effect or click on a
previous stage in the History palette.

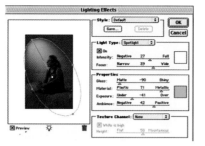

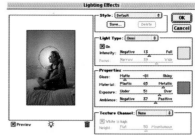

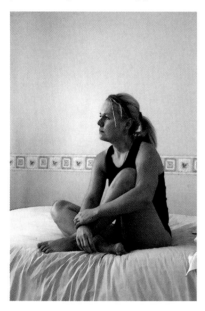

The original was lit by window from the left-
hand side and taken on a Nikon Coolpix 950
digital camera. The Watercolor filter was applied
and faded to allow the original sharper image to
dominate. Now where's the light!

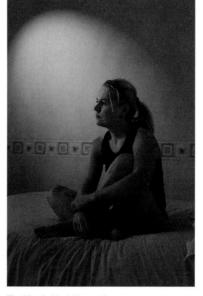

The idea behind this version was to create a
tungsten light effect. The light type was set to
spotlight with a wide, white beam and the
ambient light was yellow and underexposed to
create the natural color cast.

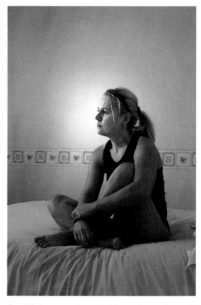

Omni light was selected with a yellow color and
the light point was placed behind the girl's head
to create a sort of backlight effect. The ambient
light was set to blue to contrast and give a
wintery feel to the room.

A spotlight effect with dark tones can be used
to place emphasis on one area of the
photograph. In this case drawing attention to
the single fish.

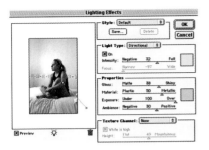

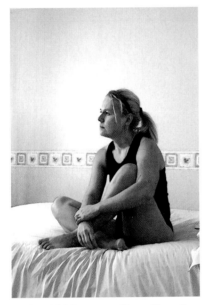

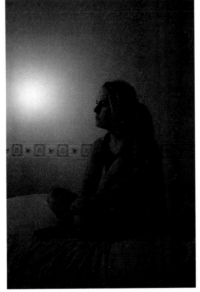

Directional lighting was used here with a yellow light set to high intensity. The ambient light was set to overexpose which has merged the yellow and purple for a romantic feel.

Omni lighting was placed higher up the wall and the color of this, and the ambient light, was set to give a dark monotone light. The idea was to create a moonlight feel which I've used below on the Stonehenge shot. Save styles you like.

A pre-set effect that gives a stage-like effect and shows the extent of the range of styles available from the Lighting filters. You can alter each light point individually for angle and width of light source.

Omni lighting was used in a similar way to the image in the middle (above). The background pixel colors have an affect on the lighting so it's not quite the moonlight effect I'd planned, but a quick tweak in color balance will sort it.

m

Magic Eraser

Another newbie from Photoshop 5.5, this tool, found in the Eraser compartment of the toolbox, is used to make pixels transparent. Click on the area you want to lose and the pixels disappear.

The palette has a number of options including the Opacity and Tolerence levels along with on/off options for anti-aliasing, Use all Layers and Contiguous modes.

Anti-aliasing makes some of the edge pixels semi-transparent to ensure edges of unremoved details are smooth for natural cutouts. Using All Layers mode makes pixels in every layer be considered by the Eraser. Contiguous mode ensures just the pixels connected to the sampled color are selected. When turned off, any pixels with a similar value within the image are selected.

All this image needed was six clicks in various parts of the sky to completely remove it. When pasted onto another background it will show through in all the areas of transparency.

Turning Anti-aliasing on ensures that edge pixels appear softer which, in turn, makes the cutout look more natural.

Magic Wand

Click on the image using this tool to select an area that has the same brightness. If for instance your subject has a blue background that you want to change to green. Click anywhere on the blue and you'll see the Magic Wand creates a selection around all the pixels that have a similar color and brightness level. Adjust the Tolerance setting to increase or decrease the range in the selection. You can also select from an individual channel which is sometimes easier.

Tip

● Holding down the Shift key as you click using the Magic Wand adds to the selection and holding down the Alt key removes from the selection.

Magnetic Pen
(See Pen tools)

Magnification box

Appears at the bottom left of a picture and lets you enter a value manually to change the size of the image on screen.

Enlarging the image on screen helps when you need to edit small areas of detail, but this may appear as blocks of pixels so you should use the Zoom tool to nip backwards and forwards.
(See Zoom tool)

Above: Image viewed on screen at 100%. Right: Image viewed at maximum 1600%.

Masks

Used to protect parts of the image when you apply filter effects or change color. They can be added to channels or layers. Select the mask from the Channels palette and the foreground and background colors appear in grayscale. You can then use the Paint and Eraser tools to add to or remove parts of the mask.

You can also save your own selections as masks by going to Select→Save Selection. This creates an Alpha channel that you can rename and use later. A mask created in the Alpha channel makes it easy to bring back complex selections. Go to Select→Load Selection to produce a selection where the black parts of the mask meet the white parts. This can be applied to any layer or channel.

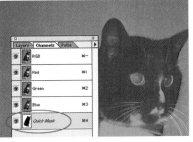

Memory

Photoshop is one of the more hungry programs, especially when you have a large History palette and several unmerged layers. As a result if your computer doesn't have loads of RAM spare you could see the performance drop and you may find filters take much longer to apply.

Click on the arrow at the bottom of the window by the file size figures and select Scratch Sizes from the drop down menu. You'll see the figures change. The new left-hand figure represents the room required for the currently opened images and the right-hand one is the space available in RAM. If the first figure is bigger than the second you're treading on thin ground and could find your computer crashes more often.

The computer will borrow memory from the hard drive and will slow down as it accesses the info. Either work with just one image open at a time or upgrade your PC and buy some more RAM.

Median filter
(See Noise filter)

m

Merging Layers

When you've finished editing an image and are sure you don't need to keep it in layers you can flatten the layers to make the image's file size much smaller. There are several ways to do this – all found near the bottom of the Layers menu.

Merge Layers and Merge Down combine the selected layer and the one below it in the Layers palette. Merge Visible combines all layers with an eye icon in front of the layer's name in the Layers palette.

Merge Linked brings together all the layers that you've selected using the linking box. Merge Group combines all the layers that you've previously grouped using the Layer→Group Linked command.

Flatten Image merges all layers that are visible and discards all the others. It's the option to choose when all your image editing is complete.

Montage

A collection of images and text brought together on one canvas using features such as Layers, Blending modes and the Rubber Stamp tool to make seamless joins.

Mezzotint filter
(See Pixelating filters)

Motion Blur
(See Blur modes)

Moiré patterns

A mottled pattern caused when printed material is converted to digital using a scanner. Some scanning software has a descreening feature that eliminates the pattern but this can soften the image.

 You can also rotate the material to be scanned slightly in the scanner and straighten it up once scanned, which some-times helps. **(See Noise filters)**

This scan of a Peacock butterfly came from a 2x1in picture in a magazine. The Moiré pattern isn't obvious when the picture is small, but as soon as you enlarged the criss-cross pattern is harsh. Use Photoshop's Median filter at a setting of around two to reduce the pattern.

Move tool

Hardly the most exciting item in the Photoshop toolbox, yet still useful. It's used to drag the image around on screen and can also be used to move Selections and Layers across to other Photoshop images.

Double click on the tool to call up the Options palette and just two options Pixel doubling and Auto Select Layer. Turn Pixel doubling on to increase the speed the tool moves the selected image in the preview. Auto Select Layer makes the tool automatically select your image's top layer.

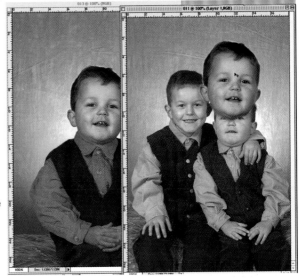

Just to prove two heads are better than one! The better expression was borrowed and blended into the other image.

Multi-page PDF to PSD

MENU **FILE →** New feature in
 AUTOMATE → Photoshop 5.5 that
 MULTI-PAGE automatically converts
 PDF TO PSD Acrobat PDF files into
Photoshop PSD. White backgrounds become transparent and images can be edited in Photoshop. Options are available to save at various resolutions in color or black & white, as seen here on Photoshop Tutorial PDF files.

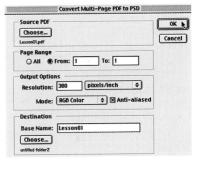

Multiply mode
(See Blending modes)

Navigator palette

MENU **WINDOW→** **SHOW NAVIGATOR** This palette shows a small preview of image you're working on. The palette preview can be made smaller or larger by dragging the bottom right edge of the box. At the base of the preview window is a zoom scale that you adjust to make the main image magnify or reduce in size. The area that shows on screen appears as a frame in the navigator's preview window which gets smaller as you increase magnification. The frame can be moved around the preview to select the area of the main image you want to work on.

Noise filter

MENU **FILTER →** **NOISE...** Four filters used to add grain or remove dust in an image to make it look natural.

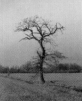

ADD NOISE

When used in small amounts this filter can make a digital picture with smoothed edges or an Illustrator file look more natural. Use in larger amounts to recreate an effect you'd obtain using fast film. Controls include an amount slider to vary from a very subtle 1 to an unbelievably gritty 999. Then you can choose between Uniform or Gaussian distribution. Gaussian produces a stronger effect. Finally turn Monochromatic on or off. When on, the Noise filter works the same on all color channels unlike off where the effect is random on each channel.

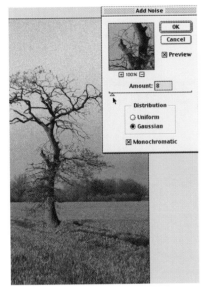
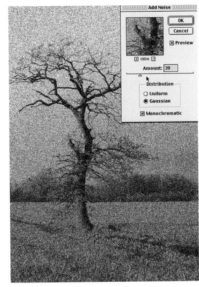
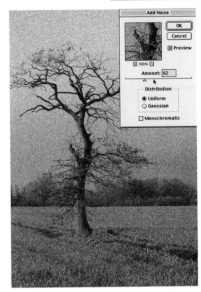

Adding 8 units of Gaussian distribution with Monochromatic selected.

Adding 39 units of Gaussian distribution with Monochromatic selected.

Adding 62 units of Uniform distribution without Monochromatic selected.

DESPECKLE

A subtle softening filter that helps reduce noise caused by poor scanning. When applied increase sharpness using the Unsharp Mask filter.

MEDIAN

Used to reduce noise, so it's quite effective with the Moiré patterns that are caused when scanning printed material. The downside is it tends to soften the image. Apply the Unsharp Mask filter to increase sharpness after this filter has been used.

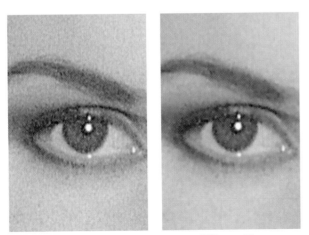

This close-up of a girl's eye was cropped from a 46Mb scan. The Despeckle filter softens the image but does help reduce some of the problems of the scan.

Median has a dialogue box with a sliding adjuster giving more control over the effect. The Moiré pattern is easily removed but the result is softer and needs the Unsharp Mask applying.

Noise filter (cont.)

MENU **FILTER →** The most useful of the Noise filter range is
 NOISE... Dust & Scratches, especially when used
on scanned films. No matter how well you try to keep the
surface clean it will attract dust and result in scans with marks.

DUST & SCRATCHES

A noise filter that detects
dramatic changes in
adjacent pixels and blurs
the surrounding colors to
smooth out the tones.

It's not always clever
enough to know what is
and what isn't dust so
don't think this is the
answer to your prayers.
You're more likely to end
up with a soft result than a
rescued one!

Try various combinations
of the two Radius and
Threshold sliders and
adjust the settings until the best result shows in the preview
window. Dragging the Radius slider to the right increases the
effect, unlike the Threshold slider which reduces it.

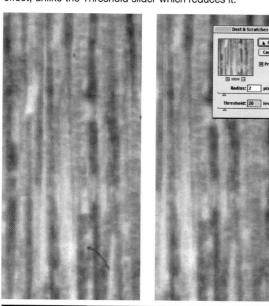

Opacity

The opacity
slider appears
in many of the
palettes and is
adjusted by
either dragging
the arrow left
or right or
typing in a new
percentage
value. Use this
mode to adjust
the layer's
appearance in
the overall
image or adjust
strengths of
paints and
editing tools.

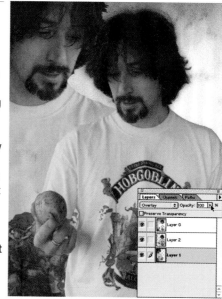

A simple image flipped and enlarged to make it look as though the person
is looking over himself. The version above with 100% opacity is too harsh
whereas the one below with 45% opacity produces a more effective result.

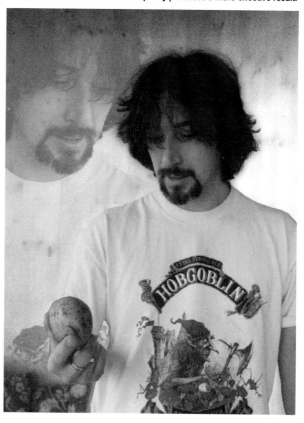

Tips

- Draw a selection around the affected area, apply a feather and then use the Dust & Scratches filter.
- Adjust the zoom ratio of the preview until the area containing the dust or scratch is visible.
- Use the Rubber Stamp tool to clone out larger blots.

Opacity set to 20%.

Opacity set to 40%.

Opacity set to 60%.

Opacity set to 80%.

Opacity set to 100%.

Setting text at various opacities can produce interesting results.

Options palette

MENU **WINDOW →**
 SHOW OPTIONS

Double clicking on anything in the toolbox brings up the Options palette that usually has a

range of settings, check boxes and sometimes greyed out items that can only be accessed when you're in certain modes. Ones at the bottom with a stylus next to them need a graphics tablet attached to be functional. The arrow at the top right lets you reset the tools.

Output levels

A slider at the base of the Levels palette is used to control the highlight and shadow detail of the image for printing. Dragging the left-hand marker right decrease shadows while dragging the right-hand marker left decreases highlights.

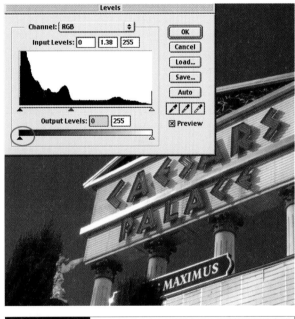

Tip

● If you get a bronzing effect on the blacks of your inkjet prints it's because too much black ink is being used. It occurs on some types of paper when they're not fully compatible with printers. Adjusting the shadow triangle from 0 to 5 or 10 reduces shadow density and helps avoid overinking the black.

Overlay mode
(See Blending modes)

p-q

Paint bucket

Use this to flood the selected area with the foreground color.

The Tolerance setting determines how many pixels are affected by the flood. A small amount results in a patchy paint effect, while a higher tolerance may color areas you don't want covered. The deckchair stripes, above, show the Tolerence at four settings. The left-hand one was set to 10, second 20, third 30 and fourth 40.

Click on Anti-aliased to soften the edge of the paint fill. The stripes, left, show anti-aliased turned on (left stripe) and off (right stripe).

Use all Layers uses pixels in all the layers to influence which ones are filled, but only fills the area on the active layer.

Paintbrush tool

One of three tools used to apply selected color to the image.

The paintbrush can be used on full strength or using the opacity setting to reduce the amount of color affecting the image. With lower opacity the original pixel color can still be seen. This effect is like adding a wash to the image and is really useful for hand-coloring black & white images.

You can also select a Blending mode to affect how the paint lays over the existing pixels. In these examples the name of the Blend mode was painted in yellow at 100% on a wall.

Dissolve

Darken

Multiply

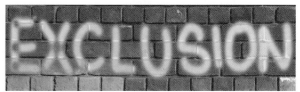

Lighten

Screen

Difference

Overlay

Exclusion

Soft Light

Hue

Hard Light

Saturation

Color Dodge

Color

Color Burn

Luminosity

p

Palettes

The menu boxes that let you adjust settings of various tools.

Arrange them carefully on the desktop to avoid clutter. Many of them have shotcut keys to open and close the window, making it visible or invisible on the desktop.
(See Appendix C)

The palettes have a wide range of options to adjust the way the features work. Spending time getting used to what they have to offer is beneficial.

You can drag one palette onto another to combine them and save space on the desktop.

Paste into

QUICK KEYS **SHIFT+CTRL+V** Used to paste an image into part of another that's been previously selected. The new pasted image appears within the selection. The area around the selection becomes a Layer Mask and the icon appears by the pasted image by the layer thumbnail.

In this example the sky was pasted into the window area.

Paths

Paths are outlines created by drawing with one of the Pen tools. They are vector based so don't contain pixels and appear separate from a normal bitmap image.

A thumbnail of the path can be viewed in the Paths palette, and from here you can select a number of options to apply to the active layer from a row of icons along the base or from the arrow's drop down menu. These options include: Filling the path with the foreground color; producing a Stroke to add the foreground color along the selected Path and making a Selection from the Path.

A Path can be moved to a new image by dragging the original path icon from the palette and pulling it over a new image. You can also copy paths from one location and paste them into another using the normal copy & paste option. Paths can be converted quickly into selections and selections can be turned into paths.

Paths are also used by designers who turn the selection into a clipping path and import it into a page layout. The clipping path ensures everything outside the frame appears as transparent on the layout. This ensures text wraps around the subject and the subject blends well with the layout.
(See Pen tools)

Use the Quick Mask mode to paint a mask around the subject.
Magnify an area and use the Eraser and Airbrush to remove or add to the mask, then convert the masked selection into a path.

One option is to fill the path with the foreground color.

Producing a Stroke to add the foreground color along the selected Path.

Making a Selection from the Path.

p

Pattern Stamp tool

Like the Rubber Stamp, but it takes the sample from a preselected area that you've defined. To use this select an area you want to clone using the Rectangular Marquee and use this to create the pattern. Then select Edit→Define pattern.

Now when you use the Pattern Stamp tool the defined area will be repeated as you draw across the canvas. If the Align box is checked the pattern will be repeated in uniform tiles in the shape of the selection. If you uncheck the Align box a tile appears wherever you draw. Blend tools are also available in this mode.

Normal blend

Dissolve blend

Hard Light blend

Difference blend

Luminosity blend

Tip
● Make your own mini gift wrapping paper by selecting a part of a subject that would look good repeated and use the Pattern Stamp tool in aligned mode to cover an A4 or A3 sheet.

Pen tool

With an icon like the nib of an ink pen this tool is used to create a path that can be turned into a selection. It's unusual to use at first, but spend some time getting familiar with it and your drawing and selection skills will improve tenfold.

The Pen tool icon on the toolbar has several options. The first is Pen tool which you use to add points, known as anchor points, around the subject. The points are automatically linked to make the path. This is ideal when you want to draw straight lines and smooth curves. You can have as many anchor points as you like and they can be removed by clicking on them.

To draw a straight line, click at a start point then move to the finish point and click again. To complete a straight path click the Pen tool icon in the toolbox when you reach the end. To complete a round path click on the original starting point to complete the shape.

The Freeform Pen tool is like the normal Lasso and creates a path wherever you draw. It's like using a normal pen and is very accurate, providing you are! Anchor points are added along the path, and their positions can be changed when the path is complete. The Magnetic Pen tool works like the Magnetic Lasso and automatically locates high contrast differences between pixels and lays the path along the edge. Use this if you're a little unsteady at drawing.

Tips
● When using the Magnetic Pen tool go slowly so the Pen locates the edge you're drawing along to ensure it picks up what you expect it to.
● Hold down the Shift key to create a straight line running at a 45° angle.
● Click the Rubber Band box in the Options palette to see the curve of the path you're about to create as you move the Pen tool.

Pencil tool

Produces a hard-edged line and is more useful for drawing than retouching images. The options palette has a fade feature that gradually reduces the pencil color opacity to zero giving a gradual fading effect. There's also an Auto erase that replaces the image with the background colour as you draw.

Perspective

MENU EDIT → TRANSFORM PERSPECTIVE Use this to either reduce converging verticals or exaggerate them. Drag the handles at the edges of the selection to pull in or pull out the canvas. A tall building that's been taken

from a low angle with a wide-angle lens will appear narrower at the top. Stretch the canvas outward to make the walls upright.

Alternatively a road going off into the distance can be made to reach a pinpoint at the horizon by pulling the canvas in at the top.

Tip

● Use View→Show Grid to help get uprights vertical.

Whoops!

● If the Transform option is greyed out go back to the picture and select the area you want to transform. Select All if it's the whole picture you're changing.

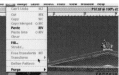

p

PICT file

Is widely used by Mac operators for use in graphics and page layout programs, and is ideal for transferring between the two. It supports RGB and allows a single Alpha channel, Index colors and Grayscale.

Pixel dimensions

The number of pixels measured along the width and height of an image, quoted, for example, as 640x480ppi on basic digital cameras and 1280x960ppi on megapixel models.

Pixelating filters

MENU FILTER → A range of
 PIXELATE seemingly pointless
filters that convert the selected area into varying patterns of clumped pixels.

Picture Package

MENU FILE →

AUTOMATE →

PICTURE PACKAGE

An auto mode that resizes a selected picture to a specified resolution and fits a variety of sizes on an A4 page, ranging from one to sixteen pictures.

CHOOSE YOUR TEMPLATE
Picture Package has a range of layouts you can choose from. This is a great automated tool to help you print multiple photos from one image on a sheet of A4 paper. It's a shame it won't automatically locate several images and print them together on one sheet – maybe on the next version!

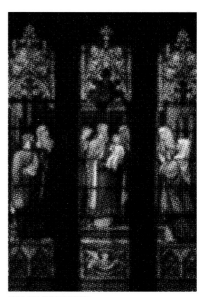

COLOR HALFTONE
Divides the image into rectangles and replaces them with circles to create an enlarged halftone effect. The menu lets you select the radius of the halftone dot, with pixel values from 4 to 127, and you can enter screen-angle values for each channel. It can take ages to apply and you'll wonder why you bothered!

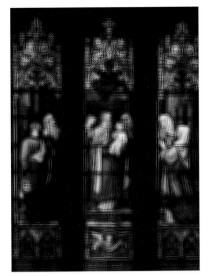

FRAGMENT
Duplicates pixels and offsets them to create an effect that you'd normally only see after a few too many drinks!

CRYSTALLIZE
Takes pixels into lumps and converts them into a polygon shape of solid color. The size of polygon can be varied between 3 and 300 pixels, although anything past 3 starts to look ridiculous.

POINTILLIZE
Makes the image look like a pointillist painting. Yuk!

MEZZOTINT
Brings up a dialogue box that has nine options – each scrambling the picture to look as though it's a badly tuned television picture. One to avoid, unless, of course, you like looking at badly tuned images!

MOSAIC
Clumps pixels into square blocks and makes them the same color. The effect is like a very low resolution image and another one we'll avoid.

FACET
One of the better pixelating filters, changes clumps of similar colored pixels into blocks of the same color pixels to make images look like they're paintings.

p

Plastic Wrap filter
(See Artistic filters)

Plug-in filters

A filter that offers additional features to the standard program. Photoshop supports third-party filters that can be added to the plug-ins folder to increase the program's flexibility. Many of the current supplied range used to be third-party options.

You can buy plug-ins such as Xaos Tools, Paint Alchemy, Kai's Power Tools, AutoFX Photo/Graphic Edges and Alien Skin's Eye Candy. Others can be downloaded from the Web.

Many more plug-ins are available as free downloads from Web sites, one of the best being PC Resources for Photoshop at *<www.netins.net/showcase /wolf359/plugins.htm>* **(See Appendix D)**

Extensis PhotoTools has some great features for making shadows, buttons and textures for use on the Web or text illustrated images. You can also emboss, add glows and use the Gif Animator to make your Web pages come alive.

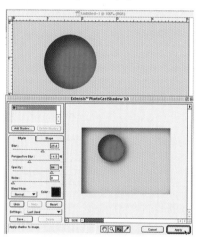

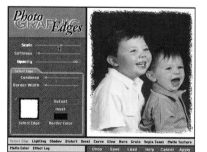

Auto F/X PhotoGraphic Edges is a useful plug-in that adds an edge to your image. The edges range from rough ragged effects to elaborate designs. Some emulate the edges that you'd get using Polaroid – a technique that's often used by fashion photographers.

Each edge can be edited to alter the depth, width, density, etc. Use this to give your pictures the edge – oh dear!

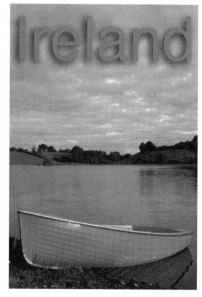

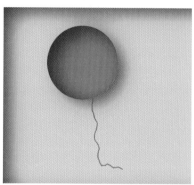

Kai's PowerTools is an amazing package of tricks from the man who invented Goo. One of the filters is a very flexible Gaussian Blur, used in this example to knock the castle out of focus.

First select the area you want out of focus in Photoshop. Add a large feather to avoid a harsh edge and call up the Gaussian Blur filter. The preview is quicker than Photoshop's too.

Kai's PowerTools has a few other gimmicks that are exciting the first time you discover them, but the novelty soon wears off.

Here the same picture was massacred twice using the Planar Tiling mode in Parquet tiling (right) and Planar tiling (below).

The Page Curl filter, from Kai's PhotoTools could be used for special effect in a presentation or brochure, but is a little too gimmicky for normal use.

The Noise mode of Kai's PhotoTools adds an interesting grainy feel to the image and could be used quite effectively on black & white too.

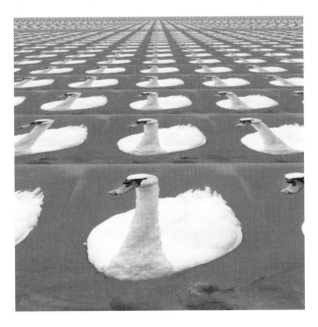

p

Plug-in filters

(cont.)

Kai's PowerTools Texture Explorer is great for making backgrounds or sandwiching images with a funky texture.

Extensis Intellihance Pro is a powerful program with multi-window previews, right, to check for color accuracy and sharpness. Pre-set corrections can be saved and applied to images later.

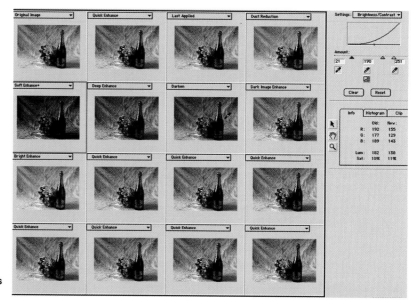

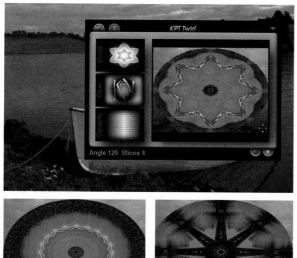

Above: Kai's PowerTools Twirl feature, set to Kaleidoscope mode, plays havoc with your images. Right: A useful test strip printer from Vivid Details shows various versions of the image that you can print out to determine color balance in as little as 1% increments.

Posterization

MENU IMAGE →

ADJUST →

POSTERIZE

Converts the image into a number of brightness levels between 2 and 255 to produce a graphic effect. 2 is too harsh, 255 too subtle. A good balance is between four and eight.

Posterization set to 2 levels.

Posterization set to 4 levels.

Left:
Posterization set to 3 levels clearly shows defined color steps that can be too harsh for many subjects.

Below:
Posterization set to 6 levels produces a much better result with many subjects.

Posterization set to 6 levels.

Posterization set to 8 levels.

Posterization set to 10 levels.

Preferences

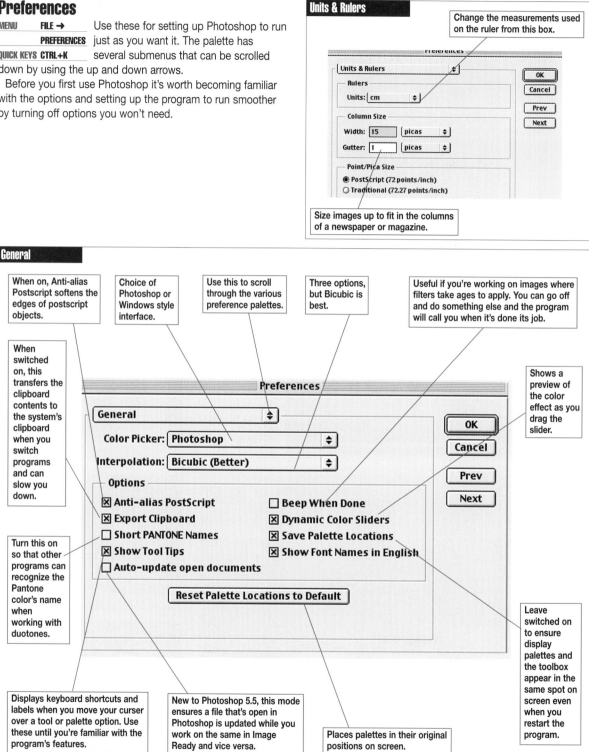

MENU **FILE →**
 PREFERENCES
QUICK KEYS CTRL+K

Use these for setting up Photoshop to run just as you want it. The palette has several submenus that can be scrolled down by using the up and down arrows.

Before you first use Photoshop it's worth becoming familiar with the options and setting up the program to run smoother by turning off options you won't need.

Units & Rulers

Change the measurements used on the ruler from this box.

Size images up to fit in the columns of a newspaper or magazine.

General

When on, Anti-alias Postscript softens the edges of postscript objects.

Choice of Photoshop or Windows style interface.

Use this to scroll through the various preference palettes.

Three options, but Bicubic is best.

Useful if you're working on images where filters take ages to apply. You can go off and do something else and the program will call you when it's done its job.

When switched on, this transfers the clipboard contents to the system's clipboard when you switch programs and can slow you down.

Shows a preview of the color effect as you drag the slider.

Turn this on so that other programs can recognize the Pantone color's name when working with duotones.

Leave switched on to ensure display palettes and the toolbox appear in the same spot on screen even when you restart the program.

Displays keyboard shortcuts and labels when you move your curser over a tool or palette option. Use these until you're familiar with the program's features.

New to Photoshop 5.5, this mode ensures a file that's open in Photoshop is updated while you work on the same in Image Ready and vice versa.

Places palettes in their original positions on screen.

89

Saving Files

Automatically adds a three letter file description to the end of newly saved files so they can be read by Windows programs on a PC.

Never save: Saves files without previews. Always save: Saves files with previews. Ask when saving: Saves previews on individual file basis.

Preferences

Saving Files ⬦

Image Previews: Always Save ⬦

☒ Icon ☐ Full Size
☒ Macintosh Thumbnail
☒ Windows Thumbnail

Append File Extension: Never ⬦

☒ Use Lower Case

File Compatibility
☒ Include Composited Image With Layered Files

OK
Cancel
Prev
Next

Using Composited Image with Layered files creates a flattened version of the file for programs that support the Photoshop 2.5 format.

Use Lower Case adds a file extension using lower case characters (.jpg). When unchecked it adds one using upper case characters (.JPG).

Displays & Cursors

Only click Color Channels in Color if you want to see color thumbnails in the Channels boxes.

Select Use System Palette if you're using an old 8-bit monitor.

Choose Use Diffusion Dither if you only have a 256-color monitor.

Display & Cursors ⬦

Display
☐ Color Channels in Color ☐ Use Diffusion Dither
☑ Use System Palette ☒ Video LUT Animation

Painting Cursors
● Standard
○ Precise
○ Brush Size

Other Cursors
● Standard
○ Precise

OK
Cancel
Prev
Next

Choose how the cursor appears on screen. See options below.

Select Video LUT Animation to speed up the display of colors on a 24-bit monitor.

● Standard ○ Precise ○ Brush Size ○ Standard ● Precise ○ Brush Size ○ Standard ○ Precise ● Brush Size ● Standard ○ Precise ○ Standard ● Precise

Plug-Ins & Scratch Disk

Lets you choose a folder or directory from the list for plug-ins and display its contents by double-clicking the folder.

Preferences

Plug-Ins & Scratch Disks ⬦

Plug-Ins Folder
My Mac:programs:Photoshop:Plug-Ins: Choose...

Scratch Disks
First: *Startup* ⬦
Second: *None* ⬦
Third: *None* ⬦
Fourth: *None* ⬦

OK
Cancel
Prev
Next

Note: Scratch disks will remain in use until you quit Photoshop.

WARNING: If you change the plug-ins location, the usual Photoshop plug-ins, filters and scanners will be unavailable until you change back to the Plug-Ins location inside the application folder.

You can assign up to four locations for Scratch disks to improve the speed that Photoshop works, but don't use removable storage, such as a Zip drive as a location.

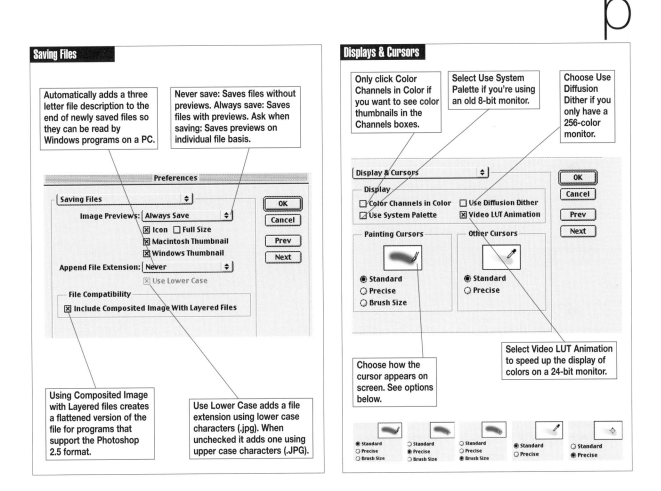

p

Transparency & Gamut

The transparent areas of a document appear as a checkerboard pattern that can be varied in size. Choose None and the transparent areas in the layer will appear white.

Use Video Alpha should only be checked if you have hardware with a chroma key facility.

Grid Colors lets you pick a grey pattern or a color.

Shows when colors in an RGB image won't print out correctly. Select a color by clicking on the square in this palette and any colors in your image that are out of the printer's gamut will appear covered with this warning color.

Guides and Grids

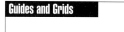

Pick a color for guides or the grid from the pre-selected range or from the Color palette. Choose one that will be seen above your images, such as bright yellow.

Enter an amount to subdivide the grid.

Choose straight lines or dashes for guides and grids.

Adjust the grid spacing by entering an amount in this box.

Image Cache

Increases the speed that a histogram appears by producing it from the Cached sample. The preview won't be as good, though.

Increase this to work faster on large files, providing you have enough RAM available for it to run smoothly.

Preserve luminosity
(See Color balance)

Preserve transparency
(See Layers)

Print resolution

The number of dots along the length and width of a print, measured in dots per inch. Generally the more dots per inch the higher the resolution. Most inkjet printers print out at between 600dpi and 1440dpi but these are slightly misleading as the figures allow for between three and six ink colors that are used to make up each dot.

A 1440dpi printer that uses six individual ink colors actually means the print resolution is more like 240dpi. The highest true resolution is around 400dpi for dye-sub printers and most books and magazines print at around 300dpi.

This close-up of the tip of a Peacock butterfly's wing (taken from the image below) shows how the dots make up the image. This is the equivalent of a 1/4in area at 300dpi, so it shows the formation of around 75 dots.

Profile to Profile

MENU	IMAGE →
	MODE →
	PROFILE TO PROFILE

Offers a wide range of profiles to convert the picture to suit the color space of the intended viewing monitor or printer output. Using this will change the colors on the working monitor and may make them look unreal.

If you select, say, RGB to Epson Color 600 using 720dpi PhotoPaper the image becomes lighter and ensures shadow detail is reproduced better.

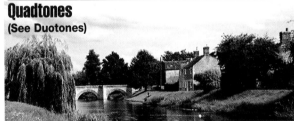

Purge command

| MENU | EDIT → |
| | PURGE |

This clears stuff out of the computer's memory such as the pattern held in the buffer ready for use by the Pattern Stamp tool.

You'd use the Purge command when the computer is starting to run slow or can't finish an action due to a lack of memory. Several options are available from the Purge drop down menu including Undo, Clipboard, Patterns, History.

Quadtones
(See Duotones)

Quick Mask mode

Enter this mode by clicking on the icon near the bottom of the toolbar. It's a quick way to create a mask around a section. The mask can be increased using one of the Painting tools or decreased using the Eraser.

When you've made all your adjustments to the mask, click the off icon at the base of the toolbar and a selection will appear on the edges where the mask meets the unmasked area. Use the Paint or erase tool set to a small brush size to clean up rough areas.

Radial Blur
(See Blur modes)

Radial Fill
(See Gradient tool)

RAM

Short for Random Access Memory – the part of the computer that's used to run programs.

Photoshop needs a minimum of 32Mb to run, 64Mb if it's going to be used for anything more than basic manipulation and as much as you can stick in to do complex multi-layer picture editing of large files.

Most computers can be upgraded and RAM, while fragile, is easy to install. You just take off the computer's side, back or lid, locate the memory slots and clip a stick of RAM into the hole. RAM used to be very expensive – a 32Mb chip cost around £900 a couple of years ago now it's around £1 per megabyte.

Raster image

Another name for a bitmap – image made up of a grid of pixels.

Replace Color

MENU **IMAGE →**
　　　ADJUST →
　　　REPLACE COLOR

Use this mode to select and change the color of your subject. The palette that appears has a fuzziness scale that works like the tolerance setting – the higher it's set the more pixels are selected around the original color. This mode is useful when the subject you want to change has a strong color dominance as it's easier to select the area you want. Set the preview window to Selection and click on either the preview image or the main image using the Eye-dropper tool to select the color you want to change.

The preview image shows the color selected as white and the surrounding areas as black. You can then adjust the Hue, Saturation and Lightness. Use the +/- Eye-droppers to add to, or remove from, the color selected.

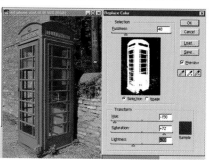

Resample Image

MENU **IMAGE →**
 IMAGE SIZE

If you want to make a picture smaller for use on a Web page, or bigger to enlarge for the wall you have to take away or add pixels – known as resampling. The Image Size palette lets you change the image using the pixel dimension or measurements. Make sure Resample Image is checked.

(See Interpolation)

Shows the size of the image in pixels or percentages. A link appears at the side when Constrain Proportions is on.

When turned on it ensures that the proportions of the width and height are maintained as one of the two values is changed.

When turned off, the file size is maintained. So, as you increase output resolution the file size dimensions are reduced.

Image Size

Pixel Dimensions: 4.5M

Width: 1024 pixels
Height: 1536 pixels

Print Size:

Width: 5.12 inches
Height: 7.68 inches
Resolution: 200 pixels/inch

☒ Constrain Proportions
☒ Resample Image: Bicubic

OK
Cancel
Auto...

If Resample Image is on the file size changes using interpolation. You then have a choice of three methods of resampling.

Gives size of output file. Can be set to inches, centimetres, pixels or percentages. A link appears when Constrain Proportions is turned on.

Resolution

(See Image Resolution)

RGB

Mode used to display colors on a computer monitor – R being Red, G green and B blue. The colors are mixed together in various proportions and intensities to create most of the visible spectrum with over 16.7 million colors.

GREEN
CYAN YELLOW
WHITE
BLUE MAGENTA RED

Photoshop assigns an intensity value to each pixel ranging from 0 (black) to 255 (white) for each of the RGB colors. Cyan, Magenta and Yellow are produced when different proportions of color overlap, for example R and G values of 255 mixed with a B value of 0 results in 100% Cyan.

Grey is created when there's an equal amount of R, G and B. When all the values are 255, the result is pure white and when the values are 0, pure black. This is known as additive color.

Ripple filter
(See Distort filters)

Rotate Canvas

MENU **IMAGE →**
 ROTATE CANVAS

Images scanned in can often appear the wrong way up or back to front. This option lets you rotate the canvas by 90° clockwise or anti-clockwise, 180° or flip horizontally or vertically.

If you take a photo with a wonky horizon you can adjust by slightly rotating the whole picture. Select Arbitary from the Rotate Canvas menu and key in the amount of rotation required in degrees.

You can also use the Transform option Edit→Transform→Rotate to rotate a selection or whole selected layer. Use the Grid option View→Show Grid to help align the horizontal or vertical elements.

r

Rubber Stamp

Some programs call the tool that looks after Cloning the, wait for it…Cloning tool! In Photoshop it's known as the Rubber Stamp tool and is responsible for many photographers taking up digital imaging.

The first time you see bits of rubbish being wiped right out of an image or spots and blemishes being removed from your partner's face you'll be in awe. All that's happening is the Rubber Stamp tool is being used to pick up or sample pixels from one place and drop them somewhere else. It's one of the most used devices.

There are several ways to use it. For starters it acts like a brush so you can change the size, allowing cloning from just one pixel wide to hundreds. You can change the opacity to produce a subtle clone effect. You can select any one of the options from the Blend menu. And, most importantly, there's a choice between Clone align or Clone non-align.

To use it place the cursor over the sample point, hold down the Alt key and click the mouse. Then move the cursor to the point where you want the sample to appear and click the mouse to dump the pixels. If you hold down the mouse button and drag you'll paint from the sample area. Select Aligned from the Rubber Stamp options palette and the sample cursor will follow the destination cursor around keeping the same distance away. When unaligned the sample cursor starts where you left off. Both choices have their advantages.
(See Pattern Stamp tool)

Scratches are fairly simple to remove. Keep a steady hand and follow patterns when Cloning.

Large objects are more difficult. Clone in the area roughly first and patch over the cloned area using other areas to create a more realistic effect.

Dust, caused by scanning an unclean transparency, can easily be removed. Just select areas of similar color or pattern from nearby and clone from those areas over the dust spot. Move in close and vary the size of the brush on different areas.

Some programs allow cloning to be applied at different percentages to produce a smaller or larger version of the original. Photoshop doesn't (right), but you can get round this by adding a new layer. Then take your sample point from the original layer and clone with the new layer active. Then use the Transform tool to rescale the cloned image (below).

Above: Clone aligned ensures the clone sample point stays at the same distance from the cursor as you move around cloning. This is useful when, for example, you're cleaning up blemishes or dust from a portrait. The sampling will always occur near to the cursor so the sampled pixels will usually be similar. In this example it's recloned the car I want to remove.

Clone unaligned keeps the sample point where you left off so when you move the cursor it stays put. This is useful when you want to take a certain part of the image and paint it in various other parts (right). Here I've taken the grass and begun to clone over the car using the same area repeatedly.

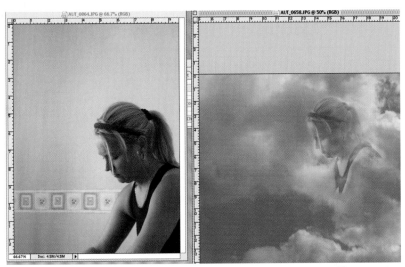

You can take your sample point from one image and then reposition the cursor on a different one to clone onto it.

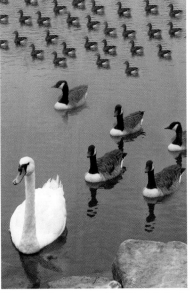

Play God and create a new life. This started out with just four birds!

S

Saturation

MENU	IMAGE →
	ADJUST →
	HUE/SATURATION

QUICK KEYS CTRL+U

A slider control to adjust the colors in the image from –100 to +100.

Dragging the slider to the left decreases the color in the image which is useful if you want a pastel effect or black & white.

Dragging to the right is the recipe for vivid colors – go too far and the image will look unnatural.

Saturation reduced to –100 knocks out all the color.

Increase to +100 and the colors become unreal.

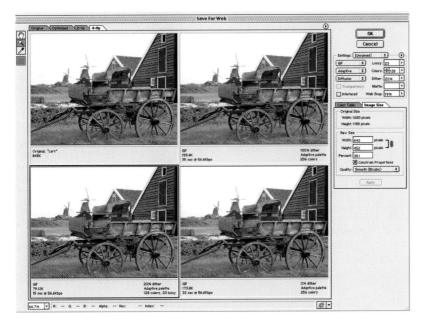

Save for Web

Version 5.5 of Photoshop shows it's taking Web production seriously, especially with this feature. Open a picture you want to convert for the Web and when you've done all your retouching or enhancing go to Save for Web.

This brings up a palette to the side of your picture with a range of options to reduce the file size by resampling, file change and color reduction.

If you're not sure what effect the various options will have on your image you can split the screen into two or four versions and apply a different setting to each.

The base of each picture has details of the new reduced file size and, very important for Web, the download time on a 56.6Kbps modem.

**GIF
79.12K
15 sec @ 56.6Kbps**

The Save for Web palette has options to vary the amount of lossy compression, as well as save the image in four different formats. The color palette can be reduced or optimized and the physical dimensions can be changed. Spend time with this mode and your Web images will fly.

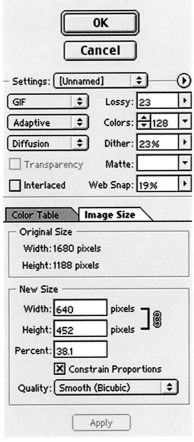

Saving

MENU	FILE ➔	Saves the current
	SAVE	version over the
QUICK KEY	CTRL+S	original. If you prefer

to keep the original and have a different file for the new adjusted image select File➔Save As (Shift+Ctrl+S) and change the name. To make things easy just add 2 at the end of the current name so you know it's version two.

The Save As option also lets you change the file format.
(See individual file formats entries)

Scale command
(See Transform)

Scratch disk

When your computer lacks the RAM needed to perform a complicated Photoshop task, the program uses its own virtual memory system known as a Scratch disk.

The Scratch disk is best assigned to the harddrive – removable drives are not recommended for this type of use. If you have partitioned your hard drive use a separate partition to hold the Scratch disk to the one that's running Photoshop for the best performance.

Selecting

When you want to edit part of an image it has to be selected. A selection can be made using several Photoshop tools such as the Lasso and Pen tools, Pens, Marquees, Magic Wand and Color Range. These are all explained in their relevant sections. The selection appears with a moving dotted line border that's often described as marching ants. Select➔All puts the marching ants around the whole image.

S

Selective color

MENU IMAGE → ADJUST SELECTIVE COLOR

Use this color correction mode to remove a color cast. The palette has a drop down menu of the six additive and subtractive primary colors along with blacks, neutrals and whites. Select which you want to modify and then adjust the Cyan, Magenta, Yellow or Black content.

Adjusting the cyan slider in the red does not affect the cyan in any of the other areas. For color casts it's often just a case of nipping into the Neutral colors and adjusting the four sliders until the image looks balanced on screen.

You also need to choose between Relative and Absolute adjustment methods. With Relative selected you adjust the cyan, magenta, yellow and black sliders by a percentage of the total. A 25% magenta pixel becomes 30% when you add 20% (20% of 25% = 5%). Add 20% using the Absolute method and a 25% magenta becomes 45% magenta.

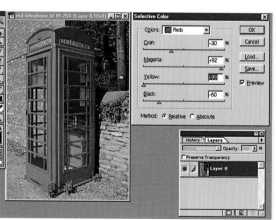

Sharpening
(See Unsharp Mask)

Sketch filters

MENU FILE→ SKETCH

A selection of filters that add hand-drawn texture to your images using the foreground and background colors.

The image becomes two tone but you could always use the History Brush to bring some more color back.

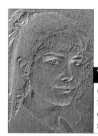

BAS RELIEF
Changes dark areas to the foreground color and light areas to the background color. Two sliders control the detail and smoothness of the effect.

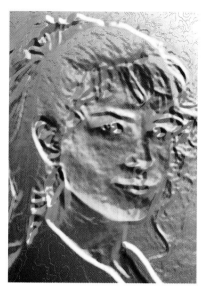

Tip
● Set Detail at maximum and Smoothness at minimum for the kind of bas relief you'd create in a darkroom, especially when foreground and background colours are set to black & white.

CHROME
Produces an image with smooth edges and a variety of grey tones, making it look like highly reflective chrome.

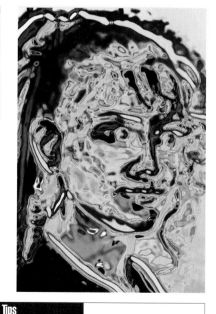

Tips
● Images can look dull when this filter has been used. Adjust Levels to add contrast to the image.
● Doesn't work well with all subjects – go for bigger subjects with less detail.

CHALK & CHARCOAL

Recreates the image with solid mid-grey highlights and midtones.

The background becomes coarse chalk using the foreground color, and shadow areas are replaced with diagonal charcoal lines using the background color. Sliders control the balance of Chalk and Charcoal and the Stroke length.

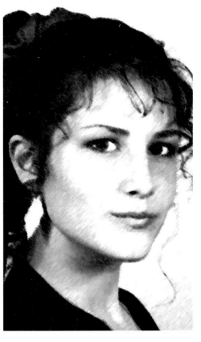

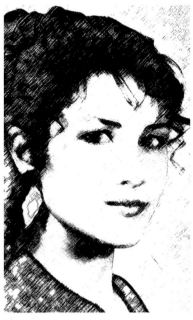

CHARCOAL

Similar effect to Chalk & Charcoal. The foreground color is sketched on top of the background color.

Tip

● Go to Filter➔Fade Charcoal and set Screen mode and an opacity of around 70% for a colorful sketch effect.

CONTÉ CRAYON

Uses the foreground color for dark areas and the background color for light areas to supposedly recreate the effect of a Conté Crayon drawing – it's more like a tapestry effect.

Sliding controls let you adjust the strength of the foreground and background colors along with the Texture, Scaling, Relief and Light direction of the effect.

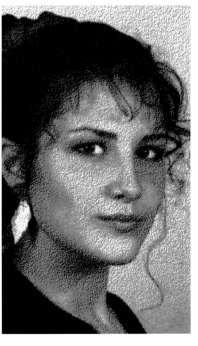

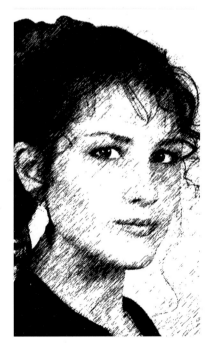

GRAPHIC PEN

Changes the image to a series of fine ink strokes which ensures detail of the original is still present. The foreground color is used for the pen's ink and the canvas becomes the background color.

Controls allow stroke length and direction to be adjusted along with the pen and paper color balance.

S

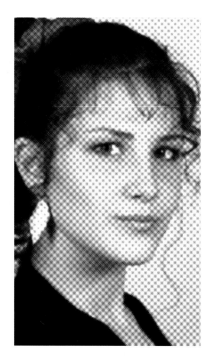

HALFTONE PATTERN

Produces a circle, dot or line pattern using the foreground and background colors.

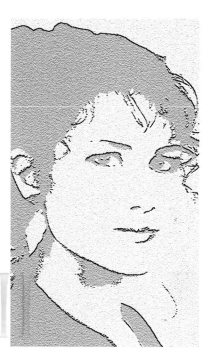

NOTE PAPER

I can't see the point of this one! Controls let you adjust the proportions of the foreground and background colors, add grain and adjust the relief of the texture. Try a few settings then give up!

RETICULATION

Use the Density, Black and White sliders to control the reticulation effect that you'd normally only achieve by accident in the darkroom.

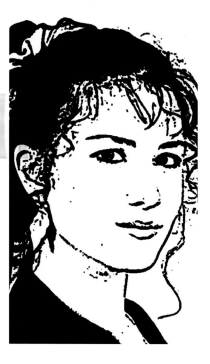

STAMP

Lightness/darkness and smoothness controls are all that are available for use with this potato-printing filter. Another one to avoid!

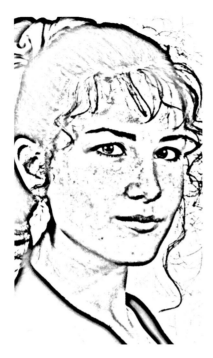

PHOTOCOPY
Another pointless effect that is supposed to turn the image into a photocopied effect. One of the filter's creators is obviously using a vintage photocopier!

PLASTER
Creates a slight 3D effect that looks like spilt fluid on a glass sheet. Dark areas are raised and light areas sink, unless you select Invert to reverse the effect.

TORN EDGES
One of the better Sketch filters that simulates a ragged paper effect. Best results are achieved by setting the Image balance slide midway; the smoothness to around 4 and the contrast to 1.

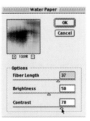

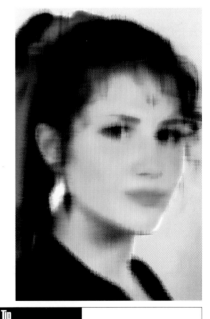

WATER PAPER
Makes the foreground and background colors flow into the image just as water color paint or ink would when applied to blotting paper.

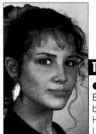

Tip

● Use the Filter→Fade… command and try different Blend modes at different opacities to mix the background image with the effect you've just applied. Here Chalk & Charcoal has been blended with Soft Light mode.

S

Smart Blur
(See Blur modes)

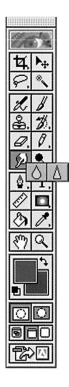

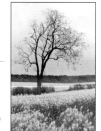

Smudge tool

Click on the finger icon that's shared by the Sharpen & Blur tools in the toolbox and use it to push or smudge color from pixels into neighbouring pixels. It creates an effect like rubbing your finger through wet paint and, as with all paint tools, you can select the size of your fingertip.

The Smudge tool can also be used to remove blemishes and spots by rubbing around the area to blend the dust spot with its surroundings.

The Smudge tool's options palette allows the Blending mode and pressure to be adjusted and it picks up the color under the pointer to paint, unless you select the Finger Painting option which uses the foreground color. Change to Finger Painting by pressing Alt (Windows) or Option (Mac OS) as you drag with the Smudge tool.

Selecting All Layers makes the Smudge tool use color from all the visible layers. When deselected it uses colors from just the active layer.

You can also choose Size or Pressure when a pressure-sensitive drawing tablet is connected. These are greyed out when not available.

The Smudge tool can also be used to blur objects by rubbing over the surface in all directions. The effect can look like water's dripped onto a water color painting.

Snapshot

Lets you make a Snapshot (temporary copy) at any stage in the editing process. The snapshot appears in a list at the top of the History pallete and can be recalled by clicking on the Snapshot you want to return to.

You can make as many snapshots as you need to compare editing stages, return to certain states or compare two or more final techniques.

Soft light mode
(See Blending modes)

Solarizing
(See Stylize filter)

Spherize filter
(See Distort filters)

Tips

● Select the Allow Non-linear History option from the triangle drop down menu in the Options palette. Then you won't lose the current History state when you return to an earlier History palette.
● Snapshots are not saved with the image. Quitting out of an image removes all snapshots.

S

Sponge tool

Shares a place with the Dodge & Burn tools in the toolbox. The icon looks like a sponge and when dragged over the image surface either increases localized saturation or decreases saturation depending on which you selected from the Options palettte.

Spot Color channels

Allows you to add and print a color that would normally not be possible from the normal CMYK gamut. You select the color using Pantone reference in a special Spot Color channel. Select New Spot Channel from the Channels drop down menu and click on the color square to call up the color picker. Ignore the Out of Gamut warning and pick that lush fluro green or pink for the vivid heading or background. Selecting 100% solidity simulates a metallic color while 0% is more like a clear varnish effect.

Tip

● The Spot Color option works best when you have the image printed with a fifth color ink. Desktop printers use CMYK so you need to add the color to the normal channels Merge Spot Channel. The printer will then simulate the color using CMYK, but it may not be as vivid.

Stroke

MENU FILE → Used to place a border around a selection
 STROKE using either foreground or background color
pixels. You can choose the width of the border, the position from the selection, Blend mode and the opacity.

Tips

● As with all border creating methods, avoid colors that clash and distract from the subject.
● Use the Stroke command when you want to highlight part of a picture. Draw a circle round it using the Circular Marquee and apply a two or three pixel stroke in an eye-catching color.

S

Stylize filter

MENU **FILTER ➔**

 STYLIZE ➔

Use these filters to create impressionist effects.

DIFFUSE

Shuffles pixels around randomly to create a soft, ragged looking image. Darken Only replaces light pixels with darker pixels. Lighten Only replaces dark pixels with lighter pixels.

EXTRUDE

Produces a 3D building block or pyramid effect. The height and size of blocks can be adjusted.

Tip

● Try applying the Pyramid Extrude after the block. Use small pixel values for the most detailed effect.

Tip

● Select Solid Front Faces to fill the front of each block with the average color. Keep it deselected to fill the front with the image.

EMBOSS

Locates high contrast edges and adds light and dark pixels to emphasize these edges. The strength of relief is increased using the Amount slider and the Height slider increases the 3D effect by making the image appear raised from its background. You can also adjust the angle that the embossing takes effect through 360°.

Emboss

OK
Cancel
☒ Preview

⊞ 100% ⊟

Angle: -130 °

Height: 2 pixels

Amount: 500 %

FIND EDGES

Emphasizes edges of a subject by detecting areas with high contrast edges and turning them black, while areas with low contrast appear white and medium contrast go grey.

Tip

● Selecting Image→Adjust→ Invert makes this look like the Glowing Edges effect.

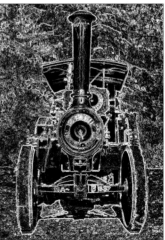

Tip

● Use the Fade command Filter→Fade Emboss Shift+Ctrl+F after applying the Emboss filter to bring back some color and detail. This example was set to Darken Blend too.

S

Stylize filter
(cont.)

MENU **FILTER →**

 STYLIZE →

Use these filters to create impressionist effects.

GLOWING EDGES
Opposite effect of Find Edges which makes the white edges that replace high contrast areas appear with a neon glow.

Tip
● Selecting Image→ Adjust→Invert makes this look like the Find Edges effect.

SOLARIZE

Produces an image like the photographic technique popularized by the likes of surrealist Man Ray where a print was exposed briefly to light during development to fog and turn highlights to black. Yuk!

TRACE CONTOUR

Creates thin outlines that vary in color around high contrast edges.

TILES

Makes the image break up into a series of tiles. You can select tile size, gaps between the tiles and the color of gaps between the tiles.

WIND

Imitates an unrealistic wind effect by producing streaks from the pixels. Three options include Wind, Blast and Stagger that can be applied coming either from the left or right.

Texture filters

MENU **FILTER ➜** A series of filters that gives the image a
 TEXTURE ➜ textured appearance as though it has been
ironed onto a textured surface.

CRAQUELURE
Produces a fine patch of
cracks that looks a little
like flaking paint.
Choose your image
carefully!

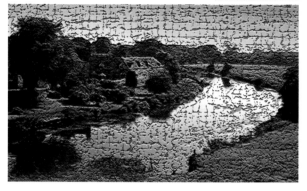

GRAIN
Adds grain to an image making it look more like a
traditional photograph. This is a useful mode to
apply to make a digital camera image blend with a
traditional shot and look more natural when
combined. There's a choice of grain types and the
intensity and contrast can be controlled.

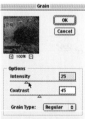

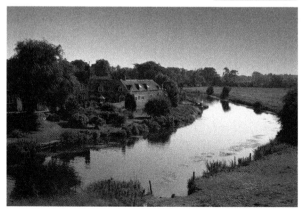

MOSAIC TILES

Breaks the image up into tiles separated by grout. The size of tiles can be adjusted along with the width and contrast of the grout.

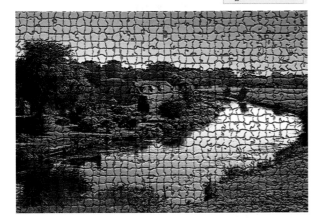

PATCHWORK

Changes the image into a grid of colored squares. The colors produced are an average of all the enclosed pixels of each particular square. The size of grid can be changed and they appear in varying depths to simulate a very realistic looking patchwork.

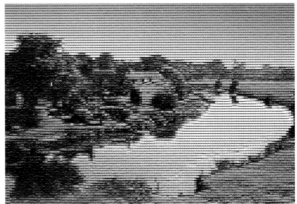

STAINED GLASS

Draws a series of irregular shaped cells over the image, outlined by the foreground color, and fills them with an average of the contained pixels. The cell and border size can be changed.

TEXTURIZER

Adds a texture to the image making it look like it's printed on canvas.

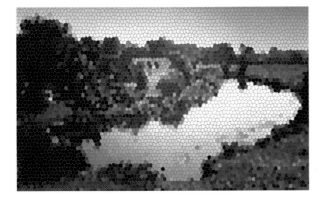

TIFF format (Tagged-Image File Format)

A versatile format that can easily be read by Macs and PCs using a variety of software programs. It supports CMYK, RGB, and grayscale files with Alpha channels plus Lab, indexed-color and Bitmaps without Alpha channels. TIFF files can be compressed, without any loss in quality, using the LZW method to gain storage space, but they'll be slower to open and save.

Tiles filter
(See Stylize filters)

Tolerance settings
(See Magic Wand)

Tritone
(See Duotones)

t

Threshold mode

MENU **IMAGE →**

 AJUST →

 THRESHOLD

Makes a normal grayscale or color image appear like a high contrast lith image by discarding all tones including greys and leaving just black and white.

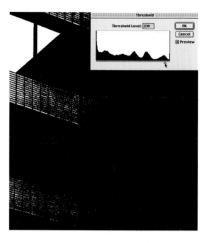

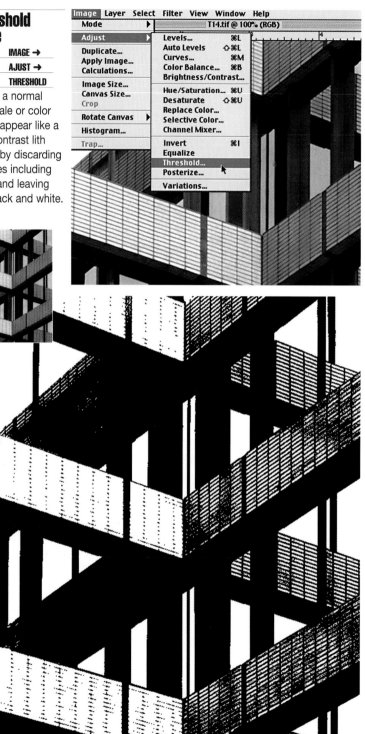

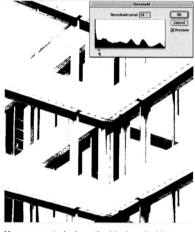

You can control where the black and white crossover points are using a slider on the Histogram.

Toolbox

The area on the desktop where all the tools are located. Ones with arrows have pull-out sections with a choice of alternative tools.

 Most of the toolbox icons can be double clicked to bring up the palette options box.

 The bottom two icons are new to Photoshop and allow easy transfer from Photoshop 5.5 to Image Ready.

 Shortcut keys are given throughout this book on the separate entries for toolbar contents. **(See Appendix C)**

Transform

MENU EDIT →
 TRANSFORM → A series of options that lets you change the size, shape, and perspective of a selection as well as rotate and flip it either manually or numerically.

The selection appears with squares, or handles, in the corners that you drag to change the dimensions. It's ideal for resizing an object when it's copied and pasted into another image. You can also use it to stretch landscapes and give them a panoramic feel.

The area you want to change must first be selected before you can use these modes.

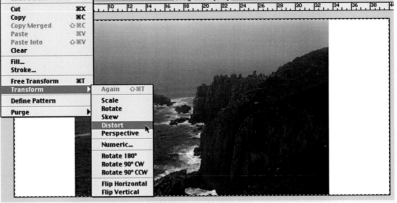

Take any ordinary landscape and stretch it using Transform→Scale to create a panoramic print.

Tip
● When making the image grow out of the canvas area increase the canvas beforehand to allow the new 'stretched' area to appear.

Use Transform→ Distort to produce fisheye style effects.

Above: Copy and resize your subject using Transform→Scale to create a realistic looking perspective.

Right: Using Transform→Skew can turn the image upside down on itself as you drag a corner point through the middle.

Transparent layer

A layer with areas that contain no pixels, such as a new Layer, appears with a chequered pattern. Any subsequent layers that are merged will only be affected by the non-transparent areas. These are only available in the Photoshop PSD format and need to be merged if saved as TIFFs or JPEGs. Transparent areas are then replaced by white. Cut-outs can be saved by converting to clipping paths which prevent the white background appearing on the document.

Transparency masks

Use the Gradient Editor with the Transparency option selected to create a transparency mask. This can be used to help blend two layers or add a graduated filter effect to an image.

Trapping

MENU IMAGE → TRAP Produces an overlap on colors by the amount of pixels you key in. The overlap prevents gaps appearing between CMYK colors if there's a slight misalignment or movement of the printing plates. This technique is known as trapping and your printer will tell you if it's needed and what values to enter in the Trap dialogue box.

TWAIN

Would you believe this is short for Technology Without An Interesting Name! It's true. Basically it's a file that comes with scanners that you place in the Preferences folder on your Mac or the TWAIN folder of the Windows Directory on a PC. When you want to scan from within Photoshop you go to File→Import→TWAIN Aquire. If you have more than one scanner installed you first have to select the one you want, File→Import→Select TWAIN Source.

The benefit is you can keep within Photoshop while scanning pictures. Once the scan is complete the image appears in a new Photoshop document named Untitled. Save the scan straightaway, because if the computer crashes you'll lose the file and will have to scan again.

Type tool

Photoshop 5's Type tool is the best the program's seen yet. As well as being able to call from the system's usual font size, color and styles you can create type with selection borders using the Type Mask tool and fill with images or textures. As the type created in Photoshop is a bitmap it appears jagged when increased or decreased greatly in size. So use a vector-based drawing package to add more adventurous type effects.

The Type Mask tool has been used with the Ivy fill and then the whole thing was pasted onto a Clouds backdrop.

In Photoshop 5.5 there are now four Anti-alias options to choose from, as opposed to on or off in Photoshop 5's palette on the left. The 5.5 palette offers None (off), Crisp, Strong and Smooth from the pull down menu. These are shown in the same order in this enlarged part of the top right of a letter S (below).

u

Undo
Use all Layers
Unsharp Mask

Undo

MENU	EDIT →
	UNDO
QUICK KEYS	CTRL+Z

If you don't like the effect of a filter you've just applied, or you've gone wrong with a brushstroke you can use Undo to take you back one step.

(For multiple undos see History palette)

Tip

● Use Undo to revert to a previous setting when making adjustments to palette settings that have several options.

Use all Layers

Select this mode in the Rubber Stamp, Paint bucket or Sharpness/Blur/ Smudge palettes to ensure the color of all layers are merged

to affect the active layer when the effect is applied. When Use all Layers is not selected only the colors in the active layer are sampled, cloned or smudged.

To show how Use all Layers mode works I used the Clone tool on this three layer image. A sample was taken from the letter R, but the streaky background layer was active. I then cloned across the image below the text resulting in just the one layer cloned. Doing the same with the Use all Layers box checked shows it picks up the word 'bear', the streaky background and the teddy making the cloning more interesting.

Unsharp Mask

MENU **FILTER →** A filter used to sharpen edges in an image and reduce
 SHARPEN → blurring caused at the photographic, scanning, resampling, or
 UNSHARP MASK printing stage. Unsharp Mask locates pixels that differ from
neighbouring pixels and increases their contrast.

The dialogue box has Amount, Radius and Threshold settings that are adjusted by either dragging sliders or manually entering values.

Amount changes the pixel contrast by the amount you set. When producing images for on-screen viewing you can judge the effect quite accurately and a setting of 50-100% is fine, but for printed output it's not as easy. Try a setting of between 150% and 200%.

Radius controls the number of pixels surrounding the edge pixels that will be affected by sharpening. A lower value sharpens just the edge pixels while a higher value sharpens a wider band of pixels. The amount you set also depends on the size of the image – use a smaller number for a lower resolution image and increase the number for a higher resolution image. Go too high and the edges will become too contrasty.

Threshold, set at a default of 0, sharpens all the pixels. Moving the slider upwards prevents the filter from affecting pixels that are similar to neighbouring pixels. A value of between 2 and 20 is a good starting point. The higher you go the less effect Unsharp Mask will have on the image.

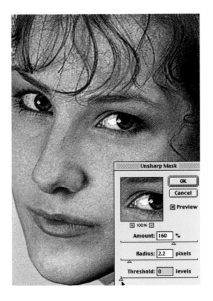
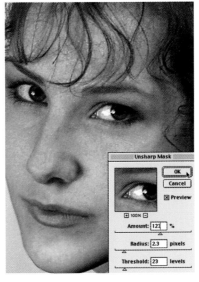

Tips

● Bright colors can become overly saturated when Unsharp Mask has been applied and dust marks are easily enhanced. Try converting the image to Lab mode and apply the filter to the Lightness channel only to sharpen the image without affecting the color.
● Run Unsharp Mask twice at half the single settings for a more subtle effect.

Above left: Apply too much Unsharp Mask and the picture will become too harsh caused by overly sharp edge detail. Above: Adjusting the setting to around 120% improves the result.

116

Variations

Watermarks
Web colors
Wet edges
Web Photo Gallery

Zoom tool

Variations

MENU IMAGE →
 ADJUST →
 VARIATIONS

This color balance control, that also lets you adjust image contrast and brightness, is the most colorful window of all the Photoshop dialogue boxes with its series of preview images.

The original selection and the adjusted selection appear at the top.

The menu appears at their side and from here you select Shadows, Midtones, or Highlights to adjust dark, middle or light areas.

Set the Fine/Coarse slider to control the amount of adjustment.

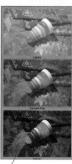

Seven pictures appear with the current example in the centre and the color options around the edges.
 To add a color to the image, click the appropriate color image and to subtract a color, click the image on the opposite side.

These three preview images are used to adjust image brightness. The centre is the current version, the one above makes the centre lighter and the one below makes it darker.

Whoops

● If the Variations command is missing from the Adjust submenu check that the Variations plug-in module has been installed.

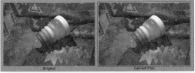

Show Clipping. This displays a neon preview of areas in the image that have become pure white or pure black as a result of your adjustments

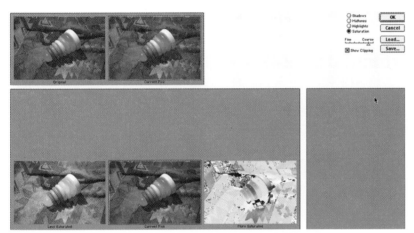

Saturation – vivid or limp.

Web colors

When using pictures on the Web there are a limited number of colors that can be selected when writing HTML code. Photoshop 5.5 lets you select the Web palette from the Color Picker and when you pick a color, the HTML reference code appears for the selected color. The blue color I picked below has an HTML code of 663399.

W

Watercolor filter
(See Artistic filters)

Watermarks

MENU **FILTER →**
 DIGIMARC
 EMBED WATERMARK

Adding a Watermark to your image is a safe way of protecting the copyright. Digimarc embeds a digital watermark to the image. It's imperceptible to the human eye but is durable in digital and printed forms and will survive typical image edits and file format conversions. A © symbol appears by the title to warn any viewers that the copyright should be respected. To use this feature you have to register with Digimarc and receive a special ID number.

Wet edges

An option in the Brush palette that produces a brushstroke with a build-up of color on the edges to simulate a watercolor paintbrush effect.

W

Web Photo Gallery

MENU **FILE ➔**
AUTOMATE ➔
WEB PHOTO GALLERY
It's never been easier to get your pictures on-line with this new feature in Photoshop version 5.5. This auto mode converts your pictures into Web manageable sizes, then writes some HTML code so that they appear as thumbnails on an opening index page. Clicking on an individual picture brings up a full screen version. The code includes arrows to navigate backwards or forwards through the gallery.

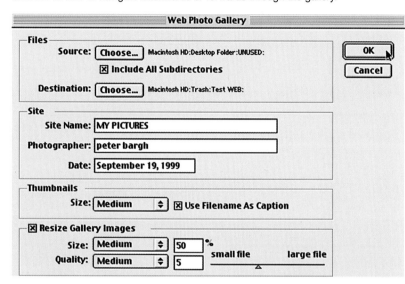

All the HTML pages, pictures and thumbnails are stored in the destination folder. Opening up the main page gives a thumbnail index of all the pictures on the site.

Click on a thumbnail to bring up a single image on a page. The arrows on the top are used to navigate through the pictures or return to the main page.

The palette has options to generate the pictures at various sizes. The site will work quicker when small files are selected, but image quality will be poorer.

ZigZag filter
(See Distort filters)

Zoom tool

QUICK KEYS **SHIFT+Z**

Used to magnify or reduce the image on screen. The zoom options palette has one choice – resize windows to fit. When selected the window grows or contracts with the image.

When PC users click on the right-hand mouse key with the Zoom tool selected you're greeted with a new menu to fit to screen, view at 100% or print size. You can also select zoom in and zoom out from here.

If you hold the Alt key down and click on the mouse the image will zoom out.

(See Navigator palette)

Zoom set to 237%.

Zoom set to 484%.

Zoom set to maximum 1600%.

Index

Appendix A: Photoshop features

Every time Adobe update Photoshop, users ask whether it's worth upgrading. Often there are only a few changes, but they're usually 'must haves', making it hard not to want to upgrade. Throughout this book I've illustrated features that come with Photoshop 5 or 5.5. If you have an earlier version or a light edition (LE), use this chart to see whether the feature is available on your copy.

Photoshop feature changes

	Version 3	Version 4	Version 5	LE	Version 5.5
Color support					
CMYK, Lab, Duotone and Multichannel	☺	☺	☺		☺
Color management including ICC			☺		☺
Color sampler			☺		☺
Color separations	☺	☺	☺		☺
RGB, Indexed Color and Grayscale	☺	☺	☺	☺	☺
Compatibility					
CMYK Import	☺	☺	☺		☺
Exports paths to Illustrator	☺	☺	☺		☺
Imports Illustrator, PostScript and Acrobat files	☺	☺	☺		☺
Creative features					
3D Transform plug-in			☺		☺
Adkustment Layers		☺	☺		☺
Art History Brush					☺
Auto editing using the Actions palette		☺	☺		☺
Auto Shadow, Bevel, Glow			☺		☺
Background & Magic Eraser					☺
Batch processing		☺	☺		☺
Channel editing			☺		☺
Color correction controls	☺	☺	☺	☺	☺
Color Range command	☺	☺	☺		☺
Contact sheet			☺		☺
Digital Watermark		☺	☺		☺
Extract Image command					☺
Guides & Grids for precise alignment		☺	☺		☺
History palette for multiple undo			☺		☺
Layers	☺	☺	☺	☺	☺
Layer alignment			☺		☺
Layer effects			☺		☺
Measuring tool			☺		☺
Magnetic Lasso			☺	☺	☺
Magnetic Pen			☺		☺
Navigator		☺	☺	☺	☺
Number of special effects filters	42+	90+		95+	95+
Painting tools	☺	☺	☺	☺	☺
Paths	☺	☺	☺		☺
Retouching tools	☺	☺	☺	☺	☺
Spot color channels			☺		☺
Text tools	☺	☺	☺	☺	☺
Web support					
Import/export GIF, KPEG and PNG files				☺	☺
Image Ready 2.0					☺
Image slicing					☺
Web palette		☺	☺	☺	☺

Appendix B: Typefaces

Your computer will, no doubt, come preloaded with a selection of typefaces, known as fonts. These can be accessed from Photoshop's Type tool and used in a number of ways with your images.

One option is to make postcards or greetings cards and use the type as the main message. You could also use the type to caption pictures, or as a supplement to a creative image, faded back as a layer.

The main thing to consider is the font you use. A modern face used on a sepia toned collage will look out of place. This book is created using Helvetica Neue and here's a selection of other fonts that you're likely to have access to. They are all set in 12 point. Select with care!

Photoshop A to Z in Arial

Photoshop A to Z in Baskerville

Photoshop A to Z in Bauhaus 93

Photoshop A to Z in Bell MT

Photoshop A to Z in Book Antiqua

Photoshop A to Z in Bookman Old

Photoshop A to Z in Britannic Bold

Photoshop A to Z in Brush Script MT

Photoshop A to Z in Calisto MT

PHOTOSHOP A TO Z IN CAPITAL REG

Photoshop A to Z in Century Gothic

Photoshop A to Z in Century Schoolbook

Photoshop A to Z in Charcoal

Photoshop A to Z in Chicago

Photoshop A to Z in Comic Sans

Photoshop A to Z in Cooper Black

PHOTOSHOP A TO Z IN COPPER PLATE

Photoshop A to Z in Courier

PHOTOSHOP A TO Z IN DESDEMONA

Photoshop A to Z in Eurostile

Photoshop A to Z in Footlight

Photoshop A to Z in Gadget regular

Photoshop A to Z in Garamond

Photoshop A to Z in Geneva

Photoshop A to Z in Georgia

Photoshop A to Z in Gill Sans

Photoshop A to Z in Gloucester

Photoshop A to Z in Goudy Old Style

Photoshop A to Z in Harrington

Photoshop A to Z in Helvetica

Photoshop A to Z in Helvetica Neue 65

Photoshop A to Z in Impact

Photoshop A to Z in Imprint

Photoshop A to Z in Kino MT

Photoshop A to Z in Letter Gothic

Photoshop AtoZ in Lucinda Blackletter

Photoshop A to Z in Lucinda Bright

Photoshop A to Z in Matura Script

Photoshop A to Z in Minion Web

Photoshop A to Z in Mistral

Photoshop A to Z in Modern

Photoshop A to Z in Monaco

Photoshop A to Z in Mono Corsiva

Photoshop A to Z in New York

Photoshop A to Z in News Gothic

Photoshop A to Z in Onyx

Photoshop A to Z in Palatino

PHOTOSHOP A TO Z IN PERPETUA

Photoshop A to Z in Playbill

Photoshop A to Z in Rockwell

Photoshop A to Z in Sand Regular

PHOTOSHOP A TO Z IN STENCIL

Photoshop A to Z in Tahoma

Photoshop A to Z in Techno

Photoshop A to Z in Textile

Photoshop A to Z in Times

Photoshop A to Z in Trebuchet MS

Photoshop A to Z in Verdana

Appendix C: Useful shortcuts

TOOLBAR
All of the tools in Photoshop's toolbar can be accessed using shortcut keys.

Adobe online
Click here for a direct link to the Adobe Web site

Marquees: Shortcut key M
Use to select areas of an image

Move tool: Shortcut key V
Use to move selection

Lasso: Shortcut key L
Use to select areas of pixels

Magic Wand: Shortcut key W
Use to select pixels

Airbrush: Shortcut key J
Use to paint color to an image

Paintbrush: Shortcut key B
Use to paint color to an image

Rubber Stamp: Shortcut key S
Clones pixels from one area of an image to another

History Brush: Shortcut key Y
Paints from a previous History state

Eraser: Shortcut key E
Use to rub out selected pixels

Pencil: Shortcut key N
Use to draw sharp edged detail

Blur & Sharpen: Shortcut key R
Use to increase or decrease sharpness

Dodge & Burn: Shortcut key O
Use to increase or decrease exposure locally

Pen tool: Shortcut key P
Use to make smooth selections and paths

Type tool: Shortcut key T
Use to add text to your pictures

Measure: Shortcut key U
Use to check picture box size and angles

Gradient: Shortcut key G
Use to make graduated masks and color backgrounds

Paint bucket: Shortcut key K
Use to fill an area with color

Eye-dropper: Shortcut key I
Use to sample color from image

Hand: Shortcut key H
Moves the area being viewed on screen

Zoom: Shortcut key Z
Use to magnify or reduce image on screen

Foreground color: Shortcut key X
Switches between foreground and background colors

Background color: Shortcut key X
Switches between foreground and background colors

Default colors: Shortcut key D

Standard mode: Shortcut key Q
Switches between Standard and Quick Mask modes

Quick Mask mode: Shortcut key Q
Switches between Standard and Quick Mask modes

Screen mode: Shortcut key F
Switches between Standard screen (left), Full screen with menus (middle) and Full screen with no menus (right).

Program Link
Jump straight into Adobe Image Ready

BLEND MODES

All the Blend modes have shortcuts. Hold down
the Shift key + Alt with the following letters:

N	Normal
	Dissolve — I
Q	Multiply
	Screen — S
O	Overlay
	Soft Light — F
H	Hard Light
	Color Dodge — D
B	Color Burn
	Darken — K
G	Lighten
	Difference — E
X	Exclusion
	Hue — U
T	Saturation
	Color — C
Y	Luminosity

PALETTES

Keeping your desktop clear of junk is essential for clean working,
especially if you have a smaller monitor. Palettes are one of the
biggest culprits for clogging up space. Fortunately F keys will open
and close palettes with ease.

Brushes palette
F5 shows or hides it.

Info palette
F8 shows or hides it.

Color palette
F6 shows or hides it.

Actions palette
F9 shows or hides it.

Layers palette
F7 shows or hides it.

EXTRACT MODE

The Extract toolbox of
Photoshop 5.5 has the
following quick keys.

PALETTE VIEWS

The Tab key shows or hides all palettes.

Shift + Tab key shows or hides all but
the toolbox.

MOVING SELECTIONS

Use the Move tool and the up, down,
left and right arrows to move the
selection one pixel at a time.

Hold down the Shift key when using the
arrows to move the selection 10 pixels
at a time.

Appendix D: Useful Web sites

Adobe

<www.adobe.com/products/photoshop/main.html>

This appendix wouldn't be complete without including Adobe's official site. It's a stunning collection of material with galleries, downloads, articles from experts, tips pages and a user forum.

Alien Skin

The makers of Photoshop plug-ins, Xenofex and Eye Candy, have this site where you can download trial versions, read about the features, see the effects the programs create or buy full versions. You can even visit the press lounge and read the latest news, often before it reaches the magazines.

CoolType

<webdeveloper.com/design/> If text is something you want to add to your pictures, go here for some, as the name suggests, cool effects. There are plenty of step-by-step techniques to help you improve the way text looks, including fire, bevels, charcoal and chalk.

PC Resources for Photoshop

<www.netins.net/showcase/wolf359/plugcomm.htm>

Stunning, that's the only word needed to describe this site – a veritable bonanza of interesting goodies for Photoshop owners. Nicely designed and crammed with useful stuff, including 62 collections of filter effects by Andrew Buckle. Go here first.

Photoshop Tutorials

<www.rice.edu/Computer/Tutorials/ravl/pshop//>

Superb site with loads of useful material based around Photoshop 3. The layout is visually very basic but if you need to know about file formats, importing, editing, manipulating or printing, take a trip through this fantastic site.

Photoshop Plugged in

<perso.club-internet.fr/gpl/>

A collection of sites listed and rated for quality. The list includes 87 commercial sites and 63 freeware options. Each has a mark out of five for usefulness.

You can also download PDF tutorials, but be warned one of these took around 25 minutes on a standard 56Kbps modem, and it only had two pages.

Adobe Photoshop Web reference

<www.adscape.com/eyedesign/photoshop/> A very useful reference site that has plenty of Photoshop info but only on versions 3 and 4. Fortunately many of the features are available on the latest releases so it's worth a visit. There's a good section

on Actions, palettes, shortcuts and Layers. And the section on filters shows an image change to the effect you select as you click on the filter.

Ultimate Photoshop

First class site that's well design, easy to navigate and well worth a visit. Has comprehensive step-by-step tutorials, a forum where you can ask questions about Photoshop and plenty of links to free plug-ins. There's even direct links to US retail outlets selling Photoshop and plug-ins.

Photoshop org

Offers useful Photoshop tutorials, galleries, tools, job vacancies and links to other sites. When I visited there was an invite for you to redesign the site, which it needed. By the time you read this it's probably sorted.

The Plug Page

<www.boxtopsoft.com/plugpage/> Go here to find interesting plug-ins to download and expand the flexibility of Photoshop.

Xaos tools

Another site run by a software manufacturer who produces Paint Alchemy and Terrazzo. The site gives overviews of the plug-in programs with examples of work, trial downloads and upgrades.

Appendix E: Recording sheets

Use these to make notes of all your favourite filter settings.
Photocopy the sheets if you prefer not to mark this book

UNSHARP MASK

Photograph	Size	Amount	Radius	Threshold
Blue racing car	1280x960	123%	1.4	103

GAUSSIAN BLUR

Photograph	Size	Radius	Fade	Mode
Portrait of Katie	*1760x1200*	*7.3 pixels*	*70%*	*Soft light*

DUOTONES, TRITONES & QUADTONES

Photograph	Ink 1	Ink 2	Ink 3	Ink 4
Deeping village	Black	PANTONE 431 CVC	PANTONE 492 CVC	PANTONE 556 CVC

DROP SHADOW

Photograph	Mode	Color	Opacity	Angle	Global	Distance	Blur	Intensity
Web button	Multiply	Blue	75%	120°	On	5 pixels	8 pixels	75%

INNER & OUTER GLOW

Photograph	Mode	Color	Opacity	Blur	Intensity
Neon Text	Hard light	Green	75%	8 pixels	75%

BEVEL & EMBOSS

Photograph	Highlight			Shadow			Style	Angle	Depth	Blur
	Mode	Color	Opacity	Mode	Color	Opacity				
Pencils	Hue	Red	90%	Screen	Blue	70%	Inner B	23°	7	15

LIGHTING EFFECTS

Photograph	Style	Light type	Intensity	Focus	Gloss	Material	Exposure
Stonehenge	Crossing D	Omni	35	-23	39	-32	-23

Ambience	Texture channel	Height
-23	Red	88

HUE & SATURATION

Photograph	Hue	Saturation	Lightness
Robin	+27	-13	-8

Also available from Focal Press ...

Adobe Photoshop 5.5 for Photographers
Martin Evening

A professional image editor's guide to the creative use of Photoshop for the Macintosh and PC.

This has become a classic reference source written to deal directly with the needs of photographers. Whether you are an accomplished user or are just starting out, this book contains a wealth of practical advice, hints and tips to help you achieve professional-looking results.

- Includes a free CD-Rom containing tryout software

Someone has just re-written the bible, the Photoshop bible...Whether you are an expert or a beginner, this is a book that talks your language.
Digital PhotoFX

If you're one of those people who hates manuals - this book comes as a breath of fresh air.
British Journal of Photography

February 2000 • 400pp • colour throughout • 246 x 189mm • Paperback with CD-Rom
ISBN 0 240 51591 9

To order your copy call +44 (0)1865 888180 (UK) or +1 800 366 2665 (USA)
or visit the Focal Press website

www.focalpress.com
- The most comprehensive and up-to-date list of books on all aspects of media technology and practice
- Articles by industry experts on the latest techniques and technology
- The best industry job sites
- Information on major media events
- Training and support material for media courses
- A forum to discuss issues with fellow peers and leading professionals